BF697.5 .B63 C3
Caplin, Rachel.
I'm beautiful, dan

P9-APG-978

Colorado Mountain College
Quigley Library
3000 County Road 114
Glenwood Springs, CO
81601

I'M BEAUTIFUL, DAMMIT!

I'M BEAUTIFUL, DAMMIT!

WAGING YOUR OWN
CURVOLUTION

RACHEL CAPLIN

WITH TONYA SANDIS

TERRACE PUBLISHING

Publisher's Note

Quotations from published interviews with celebrities and other individuals are used for purposes of information and comment pursuant to the Fair Use Doctrine. No sponsorship or endorsement by, or affiliation with, the quoted individuals is claimed or suggested. The names of some individuals have been changed.

Published by Terrace Publishing
Copyright © 2006 Rachel Caplin and Tonya Sandis

All rights reserved. No part of this book may be reproduced
in any form or by any electronic or mechanical means, including
photocopying, recording, or other information storage and retrieval
system, without permission in writing from the publisher, except by
a reviewer who may quote brief passages in review.

Written by Rachel Caplin with Tonya Sandis
Cover and author photograph: Lois Greenfield
Handlettering on page 211: Lee Newton

Quotations from published interviews with celebrities and other individuals are
used for purposes of information and comment pursuant to the Fair Use Doctrine.
No sponsorship or endorsement by, or affiliation with, the quoted individuals is
claimed or suggested. The names of some individuals have been changed.

Printed in Canada
ISBN: 0965327590
Library of Congress Control Number: 2006900557

For wholesale order to the book trade, contact
IPG: Independent Publishers Group
312.337.0747
312.337.5985 fax
800.888.4741 orders only
orders@ipgbook.com
www.ipgbook.com

For retail orders, review copies,
or interview requests, contact
Terrace Publishing
254.753.2843
254.753.5350 fax
martha@terracepartners.com
www.terracepublishing.com

To learn more about CurvOlution, visit
www.curvolution.com

CurvOlution and the CurvOlution logo are trademarks of Tonya
Sandis and Rachel Caplin. Used under license.

THANK YOU.

I would like to extend a very hearty and gracious thank you to my
business partner in CurvOlution, Tonya Sandis, whose blood, sweat,
and tears have not only seen this book through to fruition, but who
also envisioned the layout and chapter-by-chapter formatting that
make this such a fun and playful read. Her belief in our project and
her passion for inspiring girls and women the world over, coupled
with her expertise in marketing and packaging, have enriched and
embellished this book in ways I could have never done alone.
I've learned the true meaning of teamwork through collaborating
with Tonya, and this book has been fortified immensely by her caring
and meticulous contributions. Her patience, vision, and critical
thinking were crucial in birthing this work out into the world.

Thank you also to my father for raising me and always, always being
there for me. Dad, you rock! Thank you to my mother for her support and
our evolving compassion for one another—we've come a long way baby.
Indescribably huge gratitude to my fellow spiritual warrioress, Dizarelli
Pepperoncine, The Original CurvOlution Poster Child. There is, was, and
will only ever be one Nageeny. And to Charles and my forthcoming pea
in the pod—wow! My heart and belly have never been happier.

RACHEL

Here's to you, God — thank you
for my body, mind, and spirit.

TABLE OF CONTENTS

CURVO INTRO . 10

CHAPTER 1 . 12
You're too fat to be a cheerleader!
(Growing up chunky in a skinny world.)

CHAPTER 2 . 22
Food, glorious food (Can't live with it, can't live without it.)

CHAPTER 3 . 36
Help, I'm on the StairMaster, and I can't get off!
(When you want to stop, but can't.)

CHAPTER 4 . 48
Born with booty (The art of being well endowed.)

CHAPTER 5 . 56
Big boobs, little boobs (I'll keep mine, thank you very much.)

CHAPTER 6 . 64
I'm 37 years old and weigh 150 pounds
(When does a woman ever tell you that?)

CHAPTER 7 . 76
Got jealousy? (When her perfect body is killing you.)

CHAPTER 8 . 84
Tyranny of the mirror
(When enough is enough in the looking glass.)

CHAPTER 9 . 92
Quick, pose!
(Confessions of a talented contortionist.)

CHAPTER 10 . 100
Do real men love curves? *(Curves are a girl's best friend.)*

CHAPTER 11 . 110
Hey, hey, she's a big-boned gal
(Pssst . . . never call a woman B-I-G!)

CHAPTER 12 . 120
Dressing room drama *(Get in, get out!)*

CHAPTER 13 . 128
When did belly become a bad word?
(Who cares? Free your belly!)

CHAPTER 14 . 138
Bring on the bigger bodies
(Confessions of a massage therapist.)

CHAPTER 15 . 146
CurvOlution Solution

CHAPTER 16 . 154
Get out of prison! *(Stop what you're doing!)*

CHAPTER 17 . 164
Curvo Turbo *(How to be CurvOlutionary.)*

CURVO OUTRO . 208
(Waging your own CurvOlution.)

BIBLIOGRAPHY . 212

JOIN THE CURVOLUTION . 216

CURVO INTRO

This book is dedicated to all women everywhere who have ever disliked, disowned or dissed any part of their body. Not liking our bodies kills our spirits and zaps our energy. I believe we all suffer from it at one time or another—comparing our bodies and coming up short. We've tried everything possible, but somehow can just never, ever achieve that elusive "perfect" body. Even the celebrities we think are perfect have their own insecurities. You will notice I've quoted lots of them in the following chapters, for perhaps they have one of the hardest jobs of all: trying to love themselves and have a very public career at the same time, oftentimes buckling to the pressure of the media's demands on them.

Case in point: I found out only two weeks prior that I was being flown to New York City to shoot the cover of this book, and my very first thought was, "Okay, I need to hurry up and work out more to look better." Herein lies the inherent contradiction most of us embody: the love-hate syndrome. I'd spent years trying to love my body, making incremental progress, but still jeering at my belly and inner thighs in the mirror.

I came to my senses a minute later and realized the irony of that thought, and then just had to laugh with compassion for myself and all of us: I am just one of the millions of women who suffer with this auto-response. So this book is dedicated to you: you who have ever thought you needed to lose weight or change your body in order to look good, be good, get attention, receive love, or just be okay.

I joyously present you with the following stories, experiences, and reflections. Some are irreverent and others profound. Some are bawdy and outspoken, some sweet and charming. All transmit what I've been yearning to live and feel my entire life: that we are allowed to love our bodies now!

Get inspired, get mad, get happy and laugh out loud. Most of all, have fun.

Rachel

PS. I didn't go on a diet or work out more before the shoot. It was so freeing.

YOU'RE TOO FAT TO BE A CHEERLEADER!

GROWING UP CHUNKY IN A SKINNY WORLD

*"Just me being my size and being
on TV or in a movie and succeeding
is like–hey, if she can do it,
I can do it. Girls need that because
the images that they have to fight
with are even worse than what I
had to fight with growing up."*

– Queen Latifah, entertainer[1]

It's hard to find my bone structure in my baby pictures. I was a hefty little bundle of joy, all smiles and industry as I scaled couches and posed pin-up style on quilts, boasting loads of rolls of plump flesh and boundless hope for a future full of promise and cookies. I, of course, had no idea in my innocence the torture that was to come in my growing-up years for being endowed with ample flesh. At the time, all I knew was that everyone really loved me a lot and got great joy out of pinching my dimpled cheeks, all four of them.

Rachel's Rant:
I know for a fact that we were all born loving our bodies. As toddlers we explored our bodies endlessly. We learned to hate our bodies, and what we learned we can unlearn. There is an inner lover in all of us that is dying to embrace the shape we have, be done with the idiotic bad dream of hating our bodies, and get on with the bigger business of enjoying our lives and the bodies we live them in.

There is a peculiar correlation between body size and popularity that happens very early on in school. It is odd and powerful, and it really happens. Thin kids are more popular, and chunky kids aren't. Having nothing at all to do with anything other than genetically predetermined body types, cataclysmic school caste systems mercilessly heave heavy kids down to the bottom and propel thin ones up top. So, you guessed it: Yours truly was an unpopular little tot in her early school years, dodging endless teasing on playgrounds and in hallways.

The most brutal years of one's life are spent in the ruthless grip of one's peer group. As if, in those malleable, formative years, we can possibly deal with the cruel, heartless insults from other kids. All I wanted to do in fourth grade was to please, please, oh pretty please, just grow some breasts and lose some of my baby-fat belly. I'd pray just to make it down the hallway without running into one of the school's obnoxious bullies. But that never happened, considering there were very few hallways in our small suburban school, lending my vulnerably exposed, teasable self to the constant whim of tormenting tyrants.

In sixth grade, I lived, died, and breathed waiting for my chance to finally try out for our junior high cheerleading squad. My thin, popular, next-door neighbor was a year older than I and had paved the road to my fantasy entrance into popularity when she made the squad the year before. I doggedly watched her practice the routines, and begged her to teach me how to do the splits and varsity jumps and perfect all those precise moves, lines, and positions so demonstrative of the cheerleading repertoire.

It was the end of our sixth-grade year, and I had made it through our grueling tryouts only to find out that I hadn't been picked to be on the squad. I was crushed. All I had ever dreamed of was being a cheerleader. I loved the way they got to shake their pompoms to the band, dance to the fight song, and perform cool routines. I'd awaited my chance to try out for the squad with bated breath, so excited was I by the dream of getting to be a glamorous pompom girl.

The most traumatic day of that sixth-grade year began the morning after those disastrous tryouts, as I made my tentative way past the popular boys in the schoolyard. I dreaded that stretch of sidewalk leading up to the front doors of the school. You'd have thought it was a mile long, as I held my breath, hoping that they didn't see me coming. I pepped myself up, looked straight ahead, hoping to turn invisible, and stoically aimed myself toward the door with as much resolve as an awkwardly burgeoning teen could muster against the evil leers of popular boys.

Good news traveled fast at our upper-crust suburban school, and I was put back in my fat little place by our student body's elite, who made sure to inform me that I had no place in their circle. "You're too fat to be a cheerleader" was the deadly jeer aimed at me like a torpedo, searing my tentative psyche and deflating any budding signs of confidence in myself.

I don't know how I survived it. I honestly don't. But somehow I actually did carry on living in that humiliation. Looking back at my pictures in those days, it stuns me that I was considered fat. I just wasn't skinny. I was simply a little bit chubby—barely what anyone would categorize as plump. But peer brutality ran unchecked, and any little flaw or abnormality was used as ammunition to keep the haves and have-nots securely separated from one another.

I moved along in life, bearing an internal scar that persistently ate away at my self-esteem. I remember the hounding from another popular boy who made fun of me for always skimming down the side wall of our school hallway instead of walking squarely down the middle. Can you blame me? All I wanted to do was disappear. That was my only wish in those days as far as school was concerned. In my life outside of school, however, I dreamt daily of being a dancer and cheerleader, getting to express my passions and myself publicly. I'd ceaselessly fantasize for hours at a time in my attic bedroom while kicking and twirling away to the *Flashdance* soundtrack. I'd make up elaborate schemes of how I'd steal away and become a famous performer on stage, gorgeous and skinny, showing all those stupid boys how beautiful I really was.

The next year, God love me, I tried out for cheerleading again and made it. As far as I can tell from pictures, I was pretty much the same size as the year before. And, as I mentioned before, that size was a perfectly fine size, just not quite up to par with the "in" look of the times. I went on to be part of the squad for five consecutive years, reveling in the opportunity to live out at least part of my exhibitionist dream. The popular crowd dealt with it begrudgingly, but I didn't care. I had paid my dues and had made it to my first level of accomplishment.

The next stultifying blow to my developing body image came one day while the TV inside our house blared with a football game and I finished mowing the front lawn. As I approached the front door, my father was walking out. I must have mentioned to him how excited I was about taking my new ballet class at the Jewish Center. Heavily disturbed by the Browns losing the game and slightly intoxicated by a couple of beers, my father told me I was too big to be a dancer. I never forgot that moment—the crisp smell of the autumn air rustling through the branches of our front-yard tree, the slight rip in the screen door that I stared through as tears welled up in my eyes. Who knows why he said it or what he really meant, but it was a statement I clung to and chose to pull out as self-sabotaging ammunition whenever I thought of my body or its potential.

Later, dance classes invariably elicited the teachers' well-meaning instructions to pull in my tummy. Over and over I would hear this command. And believe

me, I tried. I tried so hard to pull in my belly and make myself skinny. But it never worked—because I simply had a belly that stuck out.

All these unsolicited comments on my body size hung like lead weight on my self-esteem, driving me into behaviors with food and exercise that plagued me for years. The deadly fear of living a fat life full of heartless cruelties propelled me into compulsions that have taken decades to dissolve.

The comments didn't even necessarily have to be aimed at me and my body for me to get the pervasive message that fat was bad and skinny was good. My family, the media, and society told girls and women that they had one thing and one thing only to make it or break it in this world: the size of their bodies. I learned this message through the boys at school, my father's unconscious comments, my mother's tedious body rituals, and the skinny models and actresses who always got the man's attention.

I can never quite forget all the long road trips my family took to visit our relatives on holidays. I had a slew of aunts and female cousins who would all be judged systematically by my father as to whether they looked good or bad depending on whether they had lost or gained weight since the last time we'd seen them. I'd also notice how my father sized up women on the street or at the gym, commenting that the skinny ones were "bombshells" or that the heavier ones had no right to be wearing certain outfits because their thighs were "too big."

Meanwhile, fashion was starting to invade my teenage world, and frequent trips to The Limited and Limited Express left me depressed, as I'd compare my slight pudginess to the omnipresent, God-sized posters of waifs looking off into the distance, modeling the very gorgeous clothes I could hardly squeeze over my thighs. One particularly maiming episode happened when my mother took me to The Gap to get my first pair of real jeans. The saleswoman attempted to be polite when, after unsuccessfully struggling to fit me into their jeans, she finally suggested I'd have to try the "Husky" brand. If morale deflation were visible, you could have seen my esteem sink six feet under as every ounce of hope for being a normal size drained out of me like water through a sieve.

Somehow, I got lucky and my genetic state took a sharp turn for the thinner as I entered high school, grew a few inches, got pretty, and, with the help of obsessive exercising and dieting, got temporarily skinny.

REFLECTIONS

I now look with adoration at that cute cuddle of bulgy baby fat that was me. All those awkward pre-teen and teen photographs evoke a deep empathy and love from the grown-up Rachel for that struggling young girl in the photos. She sure had a lot of fire, energy, and drive to keep on going when the going got tough. She pushed through all the societal resistance and peer interference to pursue her dreams. Chunkiness and all, she rocked!

What about you? Can you find compassion for your own plight? Can you look at yourself in your awkward phases and just adore you for what you went through? Can you find who you were before the voices told you something was wrong with you? Your earlier self might have some very interesting things to say to you. Perhaps if we all did this, we'd find that we can create change so that we all grow up just the right size in an accepting world.

CURVO QUOTES
(IN YOUR WORDS)

"MY BALLET TEACHERS AND CLASSMATES TOLD ME MY BODY WAS THE WRONG SIZE WHEN I WAS A CHILD. I REMEMBER BEING TOLD THAT I WAS FAT, AND I REMEMBER MY MOTHER TELLING ME THAT I NEEDED TO GO ON A DIET WHEN I WAS ABOUT SEVEN YEARS OLD." – Morgana, life coach

"One of my earliest memories was when my mother told me (when I was three or four), 'You have hips for making babies.' Perhaps as a rebellion to that comment, I have never had children!" – Marilyn, tax consultant

I AM DEFINITELY A CURVY DANCER. I COME FROM A BALLET BACKGROUND (I DANCED IN A PROFESSIONAL BALLET COMPANY FOR FOUR YEARS) WHERE I WAS ENCOURAGED TO BE EXTREMELY THIN. I WAS ACTUALLY WEIGHED IN ONCE A WEEK AND FINED IF MY ARTISTIC DIRECTOR FELT I WAS TOO HEAVY. ALL OF THIS WAS TAKING PLACE JUST AS MY BODY WAS DEVELOPING AND I WAS BECOMING A WOMAN. I BEGAN TO GROW BREASTS, HIPS-CURVES! MY BODY BECAME SUCH A PROBLEM, AND I WAS SO SICK AND TIRED OF STARVING MYSELF THAT I ACTUALLY QUIT DANCING COMPLETELY. THREE YEARS LATER IN COLLEGE I BEGAN DANCING AGAIN AND REALIZED HOW MUCH I TRULY LOVED IT AND MISSED IT. I TRIED OUT FOR MY COLLEGE DANCE TEAM, WHERE THE GIRLS HAD HEALTHY, WOMANLY BODIES, AND I'VE BEEN HAPPY EVER SINCE." – Susan, dancer

"I was on the playground trying to find out how to enter the school building the first day of class, and another, bigger student asked me what grade I was in. I said, 'First.' And she said, 'You are too big for first grade.'" – Gail, realtor

CURVO INFO
(JUST THE FACTS)

According to something-fishy.org, a website dedicated to raising awareness and providing support to people with eating disorders, ballet dancers weren't always the tiny figurine-like women we see today. It wasn't until a tiny, young dancer named Marie Camargo hit big that small became all the rage. She was

such a sensation that subsequent dancers had to fit her petite stature of five foot four and weigh less than 100 pounds. Before Marie's debut on stage, ballerinas ranged in size, but Marie's small, chic body style became the mandatory look for dancers everywhere.

@ @ @

"In a desperate attempt to fit the profile and stay thin, and to please judges in competition, gymnasts and figure skaters are at an elevated risk of developing an eating disorder. As with dancers, the stresses of perfection in competition contribute to hours of rigorous practice. Gymnast Christy Henrich, rated the number two gymnast in the U.S. in 1989, died from complications due to her eating disorder in 1994 at the age of twenty-two. Nadia Comaneci, Cathy Rigby, and Kathy Johnson have all come forward and admitted battling with anorexia and bulimia." – *something-fishy.org*[2]

CELEBRITY CURVOLATION
(WHAT THE CELEBS SAY)

"No boys liked me because I was chubby. I wasn't a cheerleader. I was a nerd. My weight was a struggle for me." – Gwen Stefani, musician[3]

"GOD MADE A VERY OBVIOUS CHOICE WHEN HE MADE ME VOLUPTUOUS; WHY WOULD I GO AGAINST WHAT HE DECIDED FOR ME? MY LIMBS WORK, SO I'M NOT GOING TO COMPLAIN ABOUT THE WAY MY BODY IS SHAPED." – Drew Barrymore, actress[4]

CURVO QUERY
(ASK YOURSELF)

- ◉ Have other people made unsolicited comments about my body?

- ◉ Have those comments stuck with me?

- ◉ Did I believe those comments? Do I still believe them?

- ◉ Did I ask for those comments?

- ◉ Do I know those comments to be true, or are they simply someone else's opinion?

CURVO TURBO
(TRY THIS CURVOLUTIONARY ACT)

Make a CurvOlutionary Commitment to do everything you ever wanted, regardless of the size and shape of your body!

Yeah, so I was too fat to be a cheerleader, but only in my peers' eyes. I went right on kicking and twirling my way through that fight song anyway. And, yeah, so I was too big to be a dancer, but only in certain people's eyes. I went right on bustin' a move at every school dance possible. My own body, regardless of society's limited ideas, had lots of plans and ambitions of its own, and it wasn't about to relinquish them. I went on to win a dance contest at a nightclub in New York City; teach countless people here and abroad the Cha Cha, Swing, Roger Rabbit, and Running Man; and started my own project of fierce, curvy, real-size dancers called CurvOlution.

Is there anything you've put off doing until you were another size? Is there anything you've abandoned doing because you thought or were told you didn't have the right shape to do it?

Start up conversations with your friends about dreams you've always had, but perhaps never pursued because you feared you weren't pretty enough, skinny enough, perfect enough. Brainstorm ways you can support each other in going for your dreams in reality-based, manageable ways: taking classes, joining groups, attending open mics, performing, creating your own forums to present your talents. Do it!

CURVOSIZE
(WHY EXERCISE WHEN YOU CAN CURVOSIZE?)

So what was that favorite childlike pastime you used to love? Hopefully it was something of the active variety, because now is the time to rekindle your fascination with childlike wonder, vim, and vigor and get out there and do it! Did you like running around and flying kites? Get to it! How about skateboarding? Buy one . . . find a long stretch of unencumbered sidewalk or pathway and roll, baby, roll! What about hopscotch and jump rope?! Hopscotch and jump rope were waaaaay cardio, the total precursors to every aerobic video you now have collecting dust in your cabinet. Get on out there and have some energetic fun, burning calories with every hop, skip, and jump.

AFFIRM THE CURVE
(POSITIVELY SWEET-TALK YOURSELF)

I have the perfect body to live my life. My body gracefully carries me through my life and serves all my heart's desires perfectly.

FOOD, GLORIOUS FOOD
CAN'T LIVE WITH IT, CAN'T LIVE WITHOUT IT

*"I feel like if I don't eat,
I might lose one more pound.
But I'm starving."*

– Gwen Stefani, musician[5]

*"Food is the most primitive
form of comfort."* – Sheila Graham[6]

What was it about those big white buckets of olives that my dad brought home for me from his deli that made life just so much happier and more fun? Or those incredibly huge, luscious crumbles of joy from the chocolate-chip cheesecakes they continuously test-baked in our humble little kitchen oven? Come to think of it, the scoops of purple *Star Wars* ice cream and the caramel-fudge-nut marbled turtle ice-cream pies weren't too bad, either.

Seems nothing could bring an instant and unconditional smile to my face faster than food. And I have a feeling I learned it as soon as I popped out of the womb. My parents told me that I always did like to eat, that even as a little baby, I was always on the bottle. What I came to find out later was that the bottle was what they used to deal with any emotion, sound, movement, gesture, cry, or expression that came out of me.

"Uh, honey, I don't know what she's doing or what she wants—perhaps we should just give her a bottle," or "Oh crap! She's crying again. Feed her!" were probably the survival tactics my twenty-one-year-old parents used. Who can blame them? They were practically still babies themselves. They were just barely old enough to drink legally, still dropping acid on campus in the summer of '68 when I was born. How could they possibly know what the heck to do with a baby? We all know our easiest and most successful bonding activity with animals—feeding them. They instantly and unconditionally like us, or at least pretend to, when the food is in our hands and we generously offer it to them.

So, for me anyway, I think food was very simply the easiest and most effective way my parents had to make me like them. Problem was, I was born with some kind of overactive propensity to love food a bit too much. And so I was off to the races

> *Rachel's Rant:*
> *Humans are the luckiest creatures alive. Why else would we get so many outrageously tasty options to fuel our tanks?! You don't see many apes, snakes, or rats getting as many gourmet choices as we do at the local grocery store, pizza pub, or sushi bar, do ya?*

in developing a torrid love affair with food that proved helpful in some instances, ruinous in others.

When I first realized that I couldn't eat every single thing I wanted and still be tiny and cutesy, like I also wanted to be, I started a fun food game at the dinner table. It was called "Shove it in front of Dad—he'll eat it." I always knew that if the mashed potatoes or Domino's pizza were looking just a little too inviting, and I didn't feel like my little willpower alone could handle eating a moderate portion, I could always count on my dad to pick up the slack and effortlessly and immediately consume my portion. So I got in the habit of self-righteously cutting my portions in half and quickly shuttling the other half over in front of my dad, who would willingly take up where I had left off. It was kind of like our version of the old Life Cereal commercial. You know the one: "He likes it! Hey Mikey!" Only instead of Mikey over there with the overflowing bowl of cereal, it was dad with my extras.

This was my first lame-o, half-assed attempt at anorexia.

You see, I never had it in me to just stop eating altogether. I loved eating. Everything about eating was glorious and sumptuous to me. It never failed to be the easiest way to gratification. Food was like a giant smiley face. Food was happiness. But being skinny and anorexic was becoming all the rage in those years. It was the late '70s and early '80s, and I wanted desperately to fit in. So I continued to push over my halfsies to my dad, and he continued to comply.

I don't know exactly how long that lasted, but something must have changed because I decided that I didn't want to have to give over my food. I'd rather make different food choices that allowed me to eat everything on my plate. That is when I started concocting all sorts of irrational food superstitions that governed my life for many years. They were steeped in a system of self-regulated punishments and rewards that allowed and disallowed foods like the coming and going of the tides.

One of the first illogical decisions I made was that I was safe and sound, as long as I didn't eat a main dish. I believed that I could maintain my cute, slim frame eating everything except that nasty, high-caloric main dish. Big, heavy

protein became the enemy, while side dishes, salads, and sugar were my allies. I went about my merry little way, coaxing myself into thinking that I didn't like hamburgers or fried chicken or lasagna or pizza, but rather preferred salad, cole slaw, beans, and vegetables. Then I would rationalize that since I hadn't gorged on the big ol' fattening main dish, I was allowed to indulge in my favorite part: dessert! And boy, would I go to town on that. I was known as the girl who liked her sweets. I was unstoppable and insatiable when it came to any cake, cookie, pie, ice cream, or candy. I could out-eat the very best of them. Nothing was ever too sweet or too rich—the thicker, richer, and more indulgent, the better. And with no cost, I rationalized, for I had already made my sacrifice.

I had forgone the main dish, and now I was deserving of my reward.

And reward I did. All the way until I racked up a huge case of systemic Candida brought on by an overgrowth of the yeast that was trying unsuccessfully to break down all the sugar I had so ruthlessly dumped into my intestinal tract.

There were other games I played with food. They mainly had to do with all sorts of illogical rules I'd make up, depending on the day and my mood. It was all superstitious, kind of like the silly game we'd play when we were young: step on a crack and break your mama's back. I would daily decide the different foods that I was or was not allowed to eat and restrict myself accordingly. One day I was allowed to eat noodles, but only spaghetti noodles and nothing thicker like penne or lasagna. The next day I could eat bread, but only if it was an end piece, because they were smaller. The next extraneous rule would be something about which kind of salad dressing I could use—if it were clear, it was allowed, but if milky or opaque, strictly forbidden. There were rules around starches that would make anyone dizzy. Potatoes were okay if they were baked, not if they were fried, and questionable if they were inside a casserole. You would have thought cheese was straight from the gates of hell, since I outlawed it like the plague. But double-Dutch chocolate anything was my best friend.

My politics of food were as shifty and subject to indiscriminate change as any politician's practices. Just like a daily meteorological forecast, what was legal and illegal on the food front changed with the wind. I'd gulp down three bowls

straight of Honey Nut Cheerios, but shudder at the thought of one maraschino cherry, so laden in calories was that one shiny sphere. There was no rhyme or reason, but I faithfully subscribed to my ever-changing set of rules and regulations. Food, and my haphazard policies governing it, became my religion. It was the first thing I thought about in the morning and the last thing before going to bed.

What unfortunately happened for me was that my thoughts about food became increasingly fear-based, restrictive, and scary, taking on a life of their own. I was plagued from morning 'til night with a bombardment of conflicting and omnipresent thoughts that took up way, way too much space in my mind. I'd find myself worrying in the morning about what I was to eat that day to maintain my weight, thinking obsessively throughout the day when and where and how I could get the "treats" I so wanted. And then, at the end of the day, I'd lie awake in bed at night recounting my food inventory, deeming myself "good" or "bad" for the day and pre-deciding my next day's strategy.

Due to my high volume of food thoughts, my behavior became even more devious, subversive, and just plain silly. I would hide and hoard my food. So, wanting to maintain a cool, calm, and collected appearance, I would basically huddle in my kitchen away from friends and relatives, standing at my counter to eat. My self-esteem was so ravaged from my invisible monster that I didn't even deem myself worthy of having a proper dinner table. Even though all I thought about was food, my eating time was actually very unceremonious. You would think with all that time put into planning it, I'd at least have a nice ritual feast each day. But instead I would hole up like a cockroach and stand in my tiny kitchen, oftentimes right at the refrigerator door or caved in over a little desk, and hurriedly scarf down my food, trying to pretend like it never happened.

One of the most outrageous food behaviors born of this time was dumpster diving. A brand-new Bohemian boyfriend innocently introduced me to this pastime. For him it was a conservation-friendly way of being PC, by basically recycling what the grocers had decided was too old to sell anymore. I, however, took the guerrilla behavior to a whole new level. I learned where the very

best bakery would dump its day-old breads and bagels and would make daily deliveries to my friends and family, munching the entire time as my little Toyota sputtered about my delivery route. I'd then load my fridge and freezer with enough baked goods to feed an army.

Walking tours of ice cream stores were not uncommon. In the summertime, I would eat one ice cream cone after another, moving from one store to the next to keep from being discovered as an ice cream piglet by any of the store owners. I replicated this technique beautifully upon arriving in L.A. and finding the plethora of Russian bakeries about town with lovely apple strudels and homentaschen.

I got great joy out of all of these guerrilla food maneuvers. I thought I was cute. Funny. Endearing. Enterprising, even. All of "my people" knew me at my various target stores. They knew my favorite sweet, and I felt loved. A familiar comment coming from friends and acquaintances was, "I saw you the other day walking down the street holding an ice cream cone. You looked so happy."

I always felt a little twinge of embarrassment when I was recognized as being an "eater." My relatives would let me know that I sure was lucky I could get away with eating whatever I wanted. My father warned me that I had better get some control now, because I wouldn't always have a body that would burn off those calories, and pretty soon it would catch up with me.

The weight is not what caught up with me. My body was brewing up an internal storm that debilitated me more than any outward manifestation. Candida was the wake-up call that alerted me to a growing food addiction problem that needed attention. It took me years and years to heed that call appropriately, given that I didn't want to face the fact that I was making myself sick.

The first signs of my body's rebellion against my rollicking sugar behavior began before I even graduated high school. I had chronic "belly" problems. At the time I didn't know how to even begin to put words around the fact that I had gas all the time, so I called it a "stomachache." My parents just figured it was related to my colicky baby stage and didn't think much of it. I, however, suffered daily from a distended gut that rendered me woozy and uncomfortable.

Honestly having no idea that it had anything to do with my food choices, I went about doing what most Americans do: I went to doctors, trying to find some "thing" to blame for my problems and get rid of these endless tummy issues. No one ever asked me what I was eating. Instead, at age seventeen, I got directed all the way to a gastroenterologist who wanted to do a colonoscopy on me. When I found out that meant sticking a probe up my . . . well, let's just say not down my throat, I opted out.

I went on tolerating a digestive discomfort that rendered me unsocial most nights, bloated, and in abdominal pain. Girls in my dance classes would ask me if I was pregnant, so unusually rounded my belly was. I would regularly have to lie down on my belly to try and settle my gut. All this time I went right on sugar bingeing, having no idea that there was any correlation between my actions and my insides. Finally I got into holistic health and was introduced to a long, grueling series of elimination and allergy diets and supplements to try and get to the root of my pain. Unfortunately, I had absolutely no ability to stick to any of the restrictive food regimens, as I was a raging food and sugar addict. I'd enthusiastically try out one food plan after another, thinking that if I stuck to it a couple of days and took all the right supplements, I'd be able to kill those nasty parasites or invaders or bugs or whatever was making my digestion such a horribly dysfunctional mess.

This series of trials and errors went on and on until one day a friend heard me talking one time too many about food and my body and introduced me to a support group dealing with eating and exercise disorders. That's when I was finally able to get honest with myself and tackle my runaway love affair with all the wrong foods and obsessive behaviors surrounding them. I began to take responsibility for my actions and feel the effects of my conduct. That hurt. The last thing in the world I wanted to do was to have to change or give up anything about my eating habits. I'd had no problem whatsoever with imposing restrictions and disallowing myself many certain foods in the past, and I wanted nothing to do with any more food imperatives or penalties.

But that is exactly where the life-changing shift happened. I realized that

punishment and reward had been my entire relationship with food. I had restricted myself from certain foods that were actually good for me and then rewarded myself with foods that were destroying my body. I came to realize how warped and perverse my relationship with food was. It had nothing to do with properly nourishing my body. In fact, I so distrusted and disregarded my body that it stopped sending me any proper signals at all about what it wanted any more. Food had really been about hurting myself, not loving myself.

My revolutionary change began with self-love. I realized that I had to begin loving myself unconditionally and feeding myself properly from a new place of love, honor, and respect for myself as a deserving human on the planet. No longer could I make food choices based on a deep self-loathing, trying to whip my body into some other shape, for that would only result in my irrational and self-defeating behaviors. It was from making this choice for my health that I was finally able to put down addictive behaviors. My food choices left the realm of morality and entered the realm of health.

It was through this distinction, and this distinction only, that I've been able to maintain anything close to a sane and healthy relationship with food. This happened at age thirty-five. It took a long, long time. But the difference is remarkable. When my choices come from a loving rather than punishing mindset, I am set up for success instead of failure. I cannot lose. No, I do not eat "perfectly," whatever that means. In fact, I don't think the words "perfect" and "eat" should ever even be in the same sentence. But my entire dialogue and behavior around food has changed to one of compassion and nurture, instead of restriction and white knuckling.

BEER, COCAINE, OR BROWNIES?
(GIVE ME CHOCOLATE, OR GIVE ME DEATH!)

No discussion of food would be complete without a quick discourse on its omnipotent powers over us. Ask any recovering alcoholic, drug addict, or smoker what the hardest part of kicking the habit is, and he will tell you "staying

sober," as opposed to initially putting down the substance. Stopping a habit is simply a matter of stopping a habit. The rest is about living our lives without the substance and realizing all the reasons why we picked the darn thing up in the first place.

Food is a whole different animal because, guess what, in case you haven't noticed, we have to eat it every day or else we die. An alcoholic, coke addict, or smoker lays her vice down forever and that's it. Finito. I'm not saying it's easy to do, but she never has to get into the ring with it again. We eaters, on the other hand, have to negotiate our substance of choice *every day*. At least three times a day! A friend of mine in Narcotics Anonymous said he'd rather die than have to do just one line of cocaine a day. That was a telling moment. That's when I realized what a doozy of a dependence I had on food and how drawn I felt by its hypnotic powers.

In all of those angry days of fist-shaking at God, wondering why I had to be afflicted with such a twisted, cantankerous infatuation with food, I got only one answer: You're lucky. At least you get to have your substance of choice. Alcoholics can never have another sip again. You just have to stop before you binge, consider what you're doing, and not go so hog wild all the time. You are a foodie. Join the club.

I realized that I am actually really fortunate that food is my thing. It's delicious and shows up in so many delectable shapes, sizes, tastes, and textures. I derive more pleasure than the average bear from food. My friends, family, and dates always marvel at how much delight I take in my eating. I smell and savor everything, enjoying it to the hilt.

I recently came across some research showing that test rats deprived of taste sensation die of malnutrition! Imagine that: No taste, no life.

I'll take my scrumptious food, thank you very much!

REFLECTIONS

Miraculous things started happening when I made friends with food. For starters, I found out that I really do like main dishes. Oh-my-God, how yummy

is a nice, juicy piece of barbecued chicken, a full-on plate of eggs and tortillas, or a gorgeous piece of fish? Who would ever have thought I'd like a thick, spicy turkey burger or big slab of meatloaf?

Next, I found out that my body was more than happy to take in the proper nutrition, and a great side effect was that my craving for sugar greatly diminished. How about that? Never in a million years did I think I'd be pardoned from the insane grips of sugar cravings.

And, to top it all off, my body stayed the same size. What a remarkable concept: eat like a normal person, have a normal-sized body.

Another defining benefit was that I became a helluva lot more sociable. Now that I was not running around like some sort of underground warrior, shamefully accommodating my urges and hiding from witnesses, I could be around people more of the time, especially when it had to do with food and mealtime.

And to top it all off, I purchased a lovely, tall, round table with tall seats, celebrating my meals by eating upright and proud, like a queen.

CURVO QUOTES
(IN YOUR WORDS)

"LET US AS WOMEN BE THANKFUL FOR HEARTY APPETITES! ALLOW US TO FEEL TRUE HUNGER. I SEE SO MUCH SELF-IMPOSED STARVATION AMONG WOMEN—MYSELF INCLUDED. AND THEN WE HIDE AWAY AND EAT OUR HEARTS OUT." – SARK, author[7]

"I used to buy cookies, eat one, throw the rest away, but had to spray oven cleaner on them so that I wouldn't eat them out of the trash." – Janie, mom

"When I was in third grade, my mother put me on a liquid diet and had me wear a rubber suit at night so I could sweat off my weight." – Gail, secretary

CURVO INFO
(JUST THE FACTS)

"In one fascinating experiment, scientists deprived a group of test rats of taste sensation. Both this group and a control group were placed on normal rat diets, and in a short time the taste-deprived rats all died. When the rats were autopsied, scientists could find only one cause of death: clinical malnutrition. The scientists could come up with only one explanation—that there are important, yet unknown, physiological connections between taste and health. Similarly, hospital patients fed intravenously or through feeding tubes that bypass the mouth often report a nagging hunger for taste. To be fully nourished by food, we must experience it through tasting and chewing."
– Marc David, author[8]

@ @ @

"Population studies indicate that 63 percent of high school girls and 16 percent of boys report dieting to lose weight. Within one year, 35 percent of normal dieters progress to pathological dieting, and 20 to 30 percent of all pathological dieters progress to full or partial eating disorders. Of those, 30 to 40 percent develop full disorders within four years." *– about-face.org*[9]

@ @ @

Although jokes have long been made about addictions to sugar, research done over the years has more scientists paying attention. According to the Society for Neuroscience[10], while a candy bar or other sugar-laden treats aren't addictive to the body in the same way certain drugs are, research shows some overlap between sugar and drugs on some brain functions and other characteristics.

@ @ @

"The distinction between emotional overeating and having an eating disorder is very important. Many people walk around with the feeling that they have an eating disorder. They label themselves as 'bulimic' or as a 'compulsive overeater' and in so doing make it more difficult for them to stop the behavior. The label makes them feel their situation is hopeless. I want to assure you that even an

'officially' diagnosed eating-disordered person is not hopeless. Eating disorders, whether anorexia nervosa or bulimia nervosa, are currently being treated successfully by medical and mental health professionals all over the world."

– *Dr. Sheila Forman, author*[11]

CELEBRITY CURVOLATION
(WHAT THE CELEBS SAY)

"NOW I'M FAT BUT HAPPY. I WAS SICK AND TIRED OF STARVING MYSELF TO LOOK THIN. IT WAS NO FUN. I FEEL MORE COMFORTABLE AT THIS WEIGHT–AND I'M ENJOYING MY FOOD. I DON'T CARE WHAT PEOPLE THINK. THERE SHOULDN'T BE A STANDARD FOR HOW WE ALL SHOULD LOOK." – Liv Tyler, actress.[12] (Liv had to keep her weight down to 126 pounds during the filming of *Lord of the Rings*. As soon as the film wrapped, she increased her weight to a much more comfortable 154 pounds for her five-foot-ten-inch frame.)

"My favorite thing in the world is a box of fine European chocolates, which is, for sure, better than sex." – Alicia Silverstone, actress[13]

"LIKE AN ADDICT, I HAD TO GET RID OF RELATIONSHIPS THAT WERE UNHEALTHY–MY GYM PALS AND MY DIETING BUDDIES. STARVING MYSELF WAS THE MOST STUPID THING TO DO. LOOKING BACK, I FEEL THAT DIETING WAS REALLY MY DOWNFALL, BECAUSE IT TOOK UP SO MUCH OF MY TIME. IT WAS BORING AND A WASTE OF MY LIFE. IT'S AMAZING HOW MUCH MORE FREE TIME I HAVE NOW THAT I AM NOT WEIGHING MYSELF ALL THE TIME." – Portia de Rossi, actress[14]

"THE BIGGEST SELLER IS COOKBOOKS AND THE SECOND IS DIET BOOKS—HOW NOT TO EAT WHAT YOU'VE JUST LEARNED HOW TO COOK." – Andy Rooney, commentator[15]

CURVO QUERY
(ASK YOURSELF)

- Do I play games with food?

- Do I make up rules, regulations, and superstitions with food?

- Do I feel light and easy with food, or scared and restricted around it?

- Am I tired of feeling negative and afraid of food?

- Would I like to feel freer and easier around food?

CURVO TURBO
(TRY THIS CURVOLUTIONARY ACT)

Make a CurvOlutionary Commitment to eat foods you like. Enjoy eating. Stop when you're full. Your body will love you for it. It's not rocket science, and yet it's so simple we question it. Our bodies have certain natural hunger cravings that are responding to physiological needs. Feed your body heartily, lovingly, and with respect to its needs and fullness. You are allowed to like the foods you are eating. In fact, you are supposed to derive a certain amount of pleasure out of food. Why else would we have so infinitely many kinds of food? This variety ensures us the possibility of actually enjoying the process of fueling our bodies. Eating food is a beautiful and sensuous activity. Just remember that it is only one of the ways that we feed and nourish our bodies.

CURVOSIZE
(WHY EXERCISE WHEN YOU CAN CURVOSIZE?)

This is an easy one. Walk or bike to your favorite restaurants, cafés, and grocery stores. Okay, obviously not the ones that are a freeway away. But make an effort to localize your life and live like we used to back in the day when we walked to the village for food. Make your life more neighborly so that you can naturally create exercise around eating. Make it a point to visit stores and eateries that are a good 10- to 20-minute walk from your home. Then you get to walk home after your meal, stimulating your digestion and metabolism. You can also put a basket on your bike (I once had three on mine!) and do all of your grocery shopping locally. You will get to know your surroundings better, forge friendly relationships, and keep that body of yours in tip-top shape.

AFFIRM THE CURVE
(POSITIVELY SWEET—TALK YOURSELF)

I love eating tasty, nourishing food for my body. I eat just enough to fuel my body and to feel vital. All the food I eat makes my body sing.

HELP, I'M ON THE STAIRMASTER, AND I CAN'T GET OFF!

WHEN YOU WANT TO STOP, BUT CAN'T

~

"I started undereating, overexercising, pushing myself too hard and brutalizing my immune system. The amount of time I spent thinking about food and being upset about my body was insane." – Courtney Thorne-Smith, actress[16]

"I believe that every human being has a finite number of heartbeats. I don't intend to waste any of mine running around and doing exercises." – Neil Armstrong, astronaut[17]

'll never forget the day it all started—my obsession with changing the size of my body, that is. I was a freshman in high school and had just officially gotten my biggest crush to date with the senior soccer captain. He was cuter than cute, more popular than God, and had a girlfriend, but flirted like hell with me nonetheless. His best friend was equally as attractive, but obsessed with not being as thin, agile, and dashing as my crush. He counseled me on how to get the attention of my sweetheart, was obsessed with the skinny-mini cheerleaders, and introduced me to a new kind of neurotic preoccupation with the size of my body.

Right about that time, in the early '80s, my parents bought their first pairs of Nike running shoes and started jogging around the block. Nikes were novel in Ohio back then, and so was the idea of gratuitously circling the block in a labored trot. They were really into it, especially the contagious element of being able to log more and more laps as their fitness level increased. Their enthusiasm was catching, and I soon found myself

> ### Rachel's Rant:
> I know for a fact that you cannot love your body if you are always trying to change it. I know that you cannot change your genetics. Been there, done that, bought the T-shirt. Believe me, I tried changing my genetics. Many times. Never worked. Come to find out, I actually really like my genetics.

strapping on a new pair of running shoes and starting what was to become an insidious obsession that overtook my life quicker than a California brush fire in the middle of summer.

I was quite young at the time, a mere fourteen years old, and had an astounding capacity to increase my distance, decrease my recovery time, and spend inordinate amounts of time plotting my running schedule. What started innocently enough as a suggestion by my future boyfriend's buddy to get fit turned into a full-time ordeal, starting the moment I woke up in the morning and not ending till the very last moment when I fell asleep.

I awoke each morning planning out approximately what time I would be able to get that day's run in, depending on extraneous things like homework, family plans, boyfriends, social parties, and my minimum-wage job. While my schoolmates whirred around in the backs of the seniors' convertibles after school, I proudly ran my way up and down every street of our affluent neighborhood.

As my distance and consistency increased, so did my results. I had a killer fit body and got lots of attention—especially from my intended target. I'd route my five or six miles to innocently pass by his soccer practice, garnering all kinds of attention from him and his soccer chums. I was high. I could run and run and run.

That led me to join the track and cross-country teams. I had no interest in competing or being part of a team. I never liked sports or cared about teams and winning. All I wanted was to have an excuse to run. The teams really served as cover for my growing addiction. I could camouflage my escalating need for more and more exercise through commitment to the team. Likewise, I became a cheerleader, despising the games but loving all the jumping and dancing. I would fastidiously tabulate all the calories I was burning, translating them into how much food I could then consume. I was soon running six to ten miles daily, jumping, dancing, stubbornly walking or riding my bike everywhere, and implementing a strenuous regimen of leg lifts and abdominals, à la Jane Fonda. I'd lie sideways on my shag carpet, listening to Prince wail "dance music sex romance" while counting out the 200 lifts to each side and then the 200 crunches I'd force before being allowed to take a sip of water. I did all of this without sweating and feeling higher than a kite, physically.

Emotionally, however, something else was happening. Fear and anxiety, linked to not being able to get enough exercise, were infiltrating my life. I'd neurotically worry that someone or something was going to take away my freedom and ability to work out. I worried that an injury would prevent me from running. I couldn't stop. I didn't allow myself to take days off. The obsession began to take on a life of its own, rampantly growing like suffocating weeds.

At an age when boyfriends, romance, and sexuality were in their first bloom,

I found conflict between dating and maintaining my budding addiction. My boyfriend, the very one I had crushed so hard on, would get frustrated at me because I would delay our plans in order to finish excessively long runs. The jogging also starved away a lot of my sexual appetite. I'd expend so much energy running all those miles that oftentimes I had no desire to begin the experimentation all my peers were so into. I would go out for two-hour walks on sub-zero, icy evenings, leaving my father convinced I was having a secret sexual rendezvous. He would snidely question me about where I'd been, incredulous that I'd actually chosen the inhospitable wintry environs over carrying on with a boy.

Overexercising is not the only activity that negated my normal sexual development. My body image obsession equally deprived me of a healthy sexual drive. I found myself losing to a system of rewards and punishments with my body, overtaxing my muscles with exercise, and overstuffing my belly with the inevitable voracious binges. Most of the time I would deem myself unfit to be sexual because I was not thin enough, or so bloated from eating out of control after an exercise binge that I could hardly stand the thought of being caressed in a romantic way.

As I went on to college, I had full freedom to practice my addiction to the max. There were no parents monitoring me, no grounding, and no rules and regulations as to how I spent my time. I went hog wild. I remember the excitement of running around campus for the first time. The problem was that it never stopped there, with the good feelings. Again, departing from the normal social protocol of school days, I would sit in class, half falling asleep as all college students do, but then drive myself to run as soon as the class let out. I'd have to navigate my runs to be near bathrooms at all times because my digestive system was so unpredictably overactive due to all the nervous anxiety, rushed eating, and forced exercise.

Sometime near the end of college, the first signs of wear and tear began to slow me down, momentarily. I developed an excruciating case of tendonitis in

my hip and had to reduce my running. Right about that time, in the late '80s, I met a woman who told me she taught aerobics. I was a bit interested, since it resembled dance and involved music. But I was an exercise snob at that point, unwilling to compromise what I thought to be the most superior and hardest calorie burner.

Well, the tendonitis didn't let up, and I stopped running entirely, left to the unsatisfactory substitute of walking. As fate would have it, soon thereafter I visited my mother on the West Coast, who left me to her step aerobic video collection one day while she went to work. I stacked up the plastic, Lego-like equipment, pushed play, and discovered my next obsession. I was off to the races. It felt like step aerobics had been made just for me. An avid love affair ensued. Before long I was teaching aerobics classes, again finding the perfect camouflage for my addiction. I was good at it—being rhythmic, athletic, and dancerly—and was soon teaching up to seventeen classes a week. My career was my exercise. My exercise was my career. Life was perfect . . . for a while.

Somewhere in my late twenties, the first signs of "trouble in paradise" showed up. After years of indefatigable movement, I began to get tired. The mere thought of exhaustion terrified me, so I shoved it down by any means possible. In complete denial, I forced myself onward. But underneath all the overactivity loomed a slight but prevalent sluggishness, threatening to tumble down the perfect sandcastle in the sky I'd constructed. I chose not to heed this plea for a respite, and drove myself onward and upward.

Right about that time, I decided that Ohio wasn't big enough for me, packed up a big yellow Ryder truck, and moved to L.A. to become a fitness and dance instructor. I was speeding toward a crash, stubbornly ignoring all the messages my body sent me. A few days prior to leaving, I was on a recumbent bicycle between teaching classes, obsessively trying to thin my body down in time to be competitive with the instructors I would soon encounter in L.A. One of my fellow teachers questioned why I was on the machine. I breathlessly explained to her my strategy to lean down, while I laboriously pedaled on and on, glancing every minute or so to see if my time

was up. As soon as I let myself off the machine, I greedily slammed down three straight protein bars and began to cry. Who was I fooling? What was I doing? How much longer could I keep this up?

I didn't allow those questions to go any further. I was a dance and fitness professional and headed for greener pastures. I would be fine, just fine, I half-convinced myself as I left behind my lifelong stomping grounds for the glitter, shine, and hope of bigger and better opportunities in L.A.

Unfortunately, just like the saying goes, when I got to L.A., there I was—the same obsessed and fatiguing Rachel from before. I pushed on, however, and within days had gotten fitness teaching gigs at Crunch, 24 Hour Fitness, and Beverly Hills Health and Fitness, again teaching around fifteen classes a week. Enthusiastic and driven, I auditioned for and won an opportunity to go to Tokyo to teach for three months—the final anticlimactic leg of my compulsive exercise journey.

It was in Tokyo that I finally hit the wall. I hit it hard, and I hit it for good. I found myself alone in a foreign land with only two things to do: overexercise and overeat. It was in Tokyo that I could no longer stand to push myself through the weariness that overcame me daily. I had formerly been a pro at cranking out just one more hour of high-intensity sweating and jumping, as long as I knew I could eat and rest for a bit afterward. Prior to Tokyo, I got enough of an addictive high from my exercise to compensate for the amount of coercive drive necessary to start a class, even when I could hardly climb the stairs to get to the gym floor. Those days were long gone. My Japanese students would literally find me lying on the ground just prior to class, unable to muster the cheerfulness, pep, and vigor I'd prided myself on for so many years.

One anxiety-ridden day, I was toiling away on one of those gliding stationary machines in the gym, between the two aerobics classes I taught, thinking incessantly about the sugary treat I was going to consume whole the minute I finished. Something remarkable happened in that circuit-blowing moment. Something snapped. I had a visceral experience I will never forget. I saw myself violently hacking away at the iron cage of routine that was holding me imprisoned in this murderous gridlock of exercise and food.

I stopped the machine, started crying, and didn't stop for a long, long time. Through the help of an interpreter, I forged an unprecedented breach of contract and begged the Japanese club to let me go home. They posted shaming signs saying I was leaving due to psychological illness, and reluctantly let me leave the country. I ran to the airport and came home humble, broken, and tired.

I instantly quit my fitness profession and began my slow ascent out of the nightmare of exercise addiction. I joined a support group to help ease the compulsive and isolated feelings. The first day I committed to doing absolutely no exercise was torture. I guiltily brooded every twenty minutes or so, thinking I would blow up to 500 pounds if I didn't hurry up and burn off some calories. It took a few months before I became comfortable enough to let one day go by without exercise. Progress was slow but sure, and eventually I upped the ante to two exercise-free days per week. And then I placed moderate parameters on my exercising and limited my exercise to just one jaunt a day, for a total of two hours or less. Today, these imposed constraints seem exaggerated and unbelievable, but at the time, it was monumental progress.

As time passed my addiction lost its power. I began to resume a normal, healthy relationship with exercise. Moderate physical activity had many benefits. All the overuse injuries, repetitive movement stresses, and fatigue went away, leaving me refreshed and actually looking forward to my workout days. As well, an amazing phenomenon happened: My body stayed the same size. I was baffled. I thought for sure that if I let myself be temperate and only exercise three to four times a week, I'd become fat and lazy. Au contraire. My body seemed happier than ever, springing up to work out when the allotted time came and maintaining a strong, yet decidedly more feminine appearance.

REFLECTIONS

If I had to choose an addiction, exercise had its benefits, but I would never wish that insanity on anybody. It was a deceptive addiction, for I got so much positive feedback for my physique when I was at the very height of my compulsion that it left me confused and torn. Unfortunately, outsiders only look at the surface and see a pretty body, not stopping to question what goes into making the lean cuts and slim curves. Their admiring comments reinforced my sick behaviors.

When I walk into gyms these days, I often see illness. I see a lot of obsession, regimen, and toiling. I see overexertion, pushing too far, forcing too much, and what I call "shoulding." I'll never forget a favorite dance teacher of mine telling us to shake the "shoulds" off our shoulders and to stop "shoulding" ourselves.

As beauty, athletic, and media standards continue to pressure us into more unattainable shapes, I've found it important to increase the frequency of my reality checks.

Exercising to try to change the size and shape of our bodies will lead only to high expectations, sore disappointments, soaring obsession, and an unhealthy relationship to exercise. Many overexercisers, including top-rated fitness professionals, report bulky, oversized, fatigued bodies. Ironically, the exact opposite result of what you actually want can happen when a good thing is taken to an unnatural extreme.

CURVO QUOTES
(IN YOUR WORDS)

"Of course I've had many obsessive moments with exercise. I was a ballet dancer. I danced daily, more out of fear of losing ground than out of joy for the dance." – MaryAnn, realtor

"I still sometimes struggle with an exercise disorder. People tell me to move more because I'm disabled. Because disability is so medicalized, I grew up with a million therapists telling me they 'knew' I could do more. People treat exercise like a panacea for disability-related physical issues, and so it's a loaded, guilt-ridden experience before you even begin." – Laura, human resources

"I exercise six days a week. This is as thin as my body gets." – Jennifer, dancer

CURVO INFO
(JUST THE FACTS)

"Researchers say that prolonged, strenuous exercise stimulates the body to produce substances similar to the opiate morphine. Debate continues whether or not compulsive exercisers become physiologically addicted to these substances. If they do, then obligatory exercise is a vicious circle where the biochemical products of activity lead to a self-induced high, which in turn demands more activity to generate more biochemical products.

"Cardiovascular health requires that 2,000 to 3,500 calories be burned each week in aerobic exercise: running, jogging, dancing, brisk walking, and so forth. That can be accomplished by thirty minutes of exercising a day for six days a week, or less strenuous efforts (gardening, tennis, etc.) for an hour a day, five days a week. After 3,500 calories are burned per week, the health benefits decrease, and the risk of injury increases." – ANRED.com[18]

@ @ @

"Few adolescent girls at the end of the twentieth century are able to stop thinking about [weight and appetite control]. Instead of relaxing the imperative to lose weight and be thin, the pressure to control the body has been ratcheted

upward by an even more demanding cultural ideal: a lean, taut female body with visible musculature. This particular feminine icon requires even more attention, work, and control. . . . In this aesthetic, the traditional softness of the female body is devalued in favor of toning, muscles, and strength. Instead of poetic tributes to the velvet breast or the silken thigh, we give our highest praise to body parts whose textures suggest metal and building materials. At any given time of the day or night in the United States, a sizable number of young women, as well as men, are working out, trying to achieve 'buns' and 'abs' of steel, or legs and arms of iron. . . . Our national infatuation with 'hard bodies,' combined with the idea that bodies are perfectible, heightens the pressure on adolescents." – *Joan Jacobs Brumberg, author*[19]

CELEBRITY CURVOLATION
(WHAT THE CELEBS SAY)

"I used to be a fanatic, I used to exercise four or five times a day. [I] had to overcome the eating disorder bulimia by checking into a clinic in 1994. . . . It's important to teach people not to feel like they have to fit a certain body image. Overcoming an eating disorder myself has made me prouder than selling millions of albums." – Paula Abdul, entertainer[20]

"On my best day, I am a 7.7. I could be a hard eight if I felt great. If I went on a good run and had on my best pair of jeans, I could feel right on the money." – Julia Roberts, actress[21]

CURVO QUERY
(ASK YOURSELF)

- Am I "shoulding" myself?

- Do I have a tormented relationship with exercise, always thinking I need to do more?

- Do I punish myself with exercise?

- Do I want to exercise more?

- Have I done enough exercise?

- Am I being gentle and kind to myself, or am I forcing myself?

- Am I moderately exercising to improve my health and to feel good?

- Or am I obsessively using this exercise to try to change the size and shape or my body?

CURVO TURBO
(TRY THIS CURVOLUTIONARY ACT)

Make a CurvOlutionary Commitment to exercise primarily to *feel* good, rather than to *look* good. Exercise to nourish your body's innate desire to express and release itself. You will be utterly amazed at how happily your body will settle at its own unique, gorgeous, energetic, healthy weight. And you will look good, I promise. You will glow from the inside.

CURVOSIZE
(WHY EXERCISE WHEN YOU CAN CURVOSIZE?)

It is a daily practice to shake the "shoulds" off of our shoulders and bring exercise into the realm of the moderate and enjoyable. Our bodies want to feel strong, healthy, and active. They want to run, jump, stretch, and breathe. They do not, however, want to be forced into overly difficult and straining regimens.

Trust yourself, and trust your body. Listen to what your body wants and needs from you. Give it just enough exercise to feel alive and vital, and no more. When it comes to exercise, find maintainable and enjoyable activities you can look forward to. No forcing, no straining, no dreading. There are so many possibilities to choose from, and our bodies are way happier doing something they love!

AFFIRM THE CURVE
(POSITIVELY SWEET-TALK YOURSELF)

*My body is strong and vibrant.
It tells me exactly how much
and what kind of exercise
it wants, and I listen.*

BORN WITH BOOTY
THE ART OF BEING WELL ENDOWED

~

*"I could serve
coffee using my
rear as a ledge."*

– Jennifer Lopez, entertainer[22]

"Each body has its art."

– Gwendolyn Brooks, poet[23]

My mother has a flat butt. My father has a flat butt. I, however, was born with booty that doesn't stop. We're all of white, Russian, Jewish descent. What happened?

I absolutely do not know, but to this simple deviation in genetic structure, I owe a huge part of my identity. My bubble butt has been a defining attribute, garnering much unsolicited commentary, questioning, attention, and curiosity. Where, oh where, did a white girl get such a booty?

I started to know something was different about my rear end when boys teased me as I walked down the school halls. Ah, the good ol' school halls. How many of us can trace the origins of our current neurotic tendencies and insecurities to the decidedly dangerous school hallways? Remember, this was about 30 years ago in a predominantly white, upper-class suburb. "Rachel has a big butt" was about as creative and articulate as the boys got way back in those days.

Now let me assure you, my butt was not like the Titanic or anything. It just wasn't a flat butt like everyone else's around me. It was a little bit pert, kinetic, and energetic. I guess you could say my butt has always had a brightness all its own.

But you know how it went back in school days. If there were anything, no matter how big or small, that made you stand out in a non-media-

Rachel's Rant:
I know for a fact that it is possible to love a soft, feminine body. That body is my body. I never wanted it to be this way. In fact, if you had told me six years ago that I would actually be sporting a sweet little layer of female padding, I probably would have opted out right then. My biggest nightmare was to have an ounce of fat on me. The closer I could imitate a male physique, the better. As aging, mellowing, and de-addicting would have it, I've got curves. Like it or not. And I've found that I really like them. And so does everybody else.

championed way, then your most vulnerable insecurity was billboarded and megaphoned until you felt like raw meat just wanting to be disposed of properly, please.

While my 98.9 percent white school community simply could not understand this protrusion growing off my backside, I never thought my butt was anything extraordinary. It's not like I felt it there or noticed it there any more than any other part of my body. It's behind me, so I pretty much didn't really pay attention to it. Until, of course, I started getting teased. That's when I developed the peculiar habit of having an absolutely mandatory hand held-mirror with me at all times to check my look from behind. To this day, I always need to know what my booty looks like in every outfit: Is it too big? Is it sticking out? Am I covered enough? Am I looking too bold? Or is it just right today?

The days of being teased not only ended the minute I graduated from my mostly white, suburban high school, but actually transformed into songs of praise. The very object of my childhood torment became my precious asset (pun intended) the moment I hit the streets outside suburban Ohio. I went from being the object of bratty schoolboys' scathing jokes to being the apple of many a man's eye. Or at least my derriere did.

I soon found that I could actually get a whole lot of positive attention with the very part of my body that used to attract so much scorn. Wow, what a rush! I got on that right away, capitalizing on my genetic defect-cum-crowning glory! It wasn't long before I had completely revamped my entire wardrobe, making sure that each piece of clothing carefully sculpted, hugged, and artfully displayed my now-praised buttocks.

I even went so far as to get a bit cocky about my butt, feeling overly proud of the size of this new, wondrous discovery that attracted men. I used and abused the power of my curvy cheeks, boastfully wearing them with pride and arrogance, pitying poor, flat-butted women.

Then the tables started turning, as I began attracting only lascivious attention from men. Having at first been starved for their attention, now I

was finding myself drowning in the overkill of their lusty stares. Yuck! I didn't want that either. Of course, like most red-blooded women, I wanted men to notice me, but I surely didn't want to be seen only for the sum of my buns.

I got confused. I didn't know what to do. Wear it with pride? Tone it down? Accentuate it? Draw to it or away from it?

I started wondering if this particular part of my body would draw only a certain kind of attention from a certain kind of man. Was I doomed to never attract my marriage-material, future husband with my butt so flamboyant and lively, having a party all its own, regardless of me?

And don't even get me started on the trauma of trying to find fitted pants to accommodate my particular size. It seems that by the time the material makes its way over my rump, there is always a good three inches of waist sticking out behind my lower back. I've found myself marveling at tiny girls with flat butts trotting around in perfectly fitting jeans, while I'm also chasing down the thicker divas and imploring them to share their shopping secrets. It is an absolute rarity to find clothing that knows the curves of this behind. So, when I see a similarly bodied woman sporting flattering pants, I absolutely must stop her and ask her where she found them, what brand they are, and where can a round-behinded woman shop in this city? We invariably bond on our shared issues, sympathizing with each other's shared plight. Chuckles, giggles, and knowing nods always ensue between two women who know the complexities of clothing an endowed booty.

REFLECTIONS

Flat, round, perky, saggy, wide, narrow, juicy, or hard. Pear-shaped, apple-shaped, and moon-shaped . . . butts come in so many shapes and sizes. It's your butt! Wear it with flair.

CURVO QUOTES
(IN YOUR WORDS)

"My perception of my butt size has kept my self-esteem way down. It is still painful to look in the mirror when I am naked, but that is changing."
– Jessica, professional organizer

CURVO INFO
(JUST THE FACTS)

In Jamaica, "Voluptuousness is still valued, but today, big butts are emphasized—and proper proportion is a thing of the past. In pursuit of a supersize rear, some women even risk their health by taking animal hormone pills, used by farmers to fatten chickens, in a misguided attempt to 'grow' a larger butt. (There's no scientific evidence that it works.) 'These pills are extremely dangerous,' says Dr. Manual Pena, representative of Jamaica's Pan American Health Organization. 'They are not meant for humans. Taking them can have severe health implications, including high blood pressure and metabolic problems.'" – Marie Claire[24]

@ @ @

"Because we see so many extraordinary, hyperbolic bodies, young women today grow up worrying about specific body parts as well as their weight. . . . In the 1990s, the real heat is on the lower body, especially thighs and buttocks. The current emphasis on the lower body has to do with the commingling of aesthetic, health, and sexual imperatives that make a taut female pelvis, sleek thighs, and a sculptured behind both objects of desire and symbols of success."
– Joan Jacobs Brumberg, author[25]

CELEBRITY CURVOLATION
(WHAT THE CELEBS SAY)

"I'M OBSESSED WITH MY THIGHS. I CAN BARELY FIND JEANS THAT FIT. I RELATE TO OTHER WOMEN'S BODY ISSUES. I ONCE HEARD A LADY AT A CLUB SAY, 'THAT'S MARION JONES. GOD, SHE HAS A BIG BUTT.' THAT STUCK WITH ME." – Marion Jones, Olympic athlete[26]

"My backside seems to have become a national obsession, but I think the fuss is ridiculous. I really don't do anything to my bottom. I don't use lotions or anything like that. I work hard, I run around a lot, and I dance when I have to. But that's it." – Kylie Minogue, singer[27]

CURVO QUERY
(ASK YOURSELF)

◉ Do I get attention for parts of my body that makes me uncomfortable?

◉ Do I falsely believe there is a certain size that is "right" for my body parts to be?

◉ Do I ever "use" my body to get attention and then get angry that I only get that kind of attention?

◉ Do I think that certain sizes of certain body parts make someone better or worse than me?

CURVO TURBO
(TRY THIS CURVOLUTIONARY ACT)

Make a CurvOlutionary Commitment to expose a part of you that you normally hide. Wear clothing that accentuates the very part of you that is always hidden underneath clothing. This can be very powerful. Many women hide the parts of their bodies that they find unacceptable to the public. They often not only hide them, but also actually wear big, bulky oversized clothing to try to mask the "oversized" part. Ironically, these bulky, hanging, unflattering clothes make the problem area look even bigger. So, I suggest you highlight the very parts that you keep hidden. It is extremely liberating!

I have a good friend who is a bit short and a bit thick, full-blooded Italian, who wore huge, oversized, thick, burly sweats all the time. She felt ashamed of her short, strong stature. I never knew what her body really looked like until she finally started wearing clothes that snugly fit and accentuated her hips and legs. When she did finally become willing to stop hiding behind the oversized clothing, amazing things happened. She felt much freer to be in her body and proud of it. She got a lot of compliments from all her friends and a lot of attention from men.

CURVOSIZE
(WHY EXERCISE WHEN YOU CAN CURVOSIZE?)

Wanna get that booty flexin' and workin'? Hike! Move uphill. Find a slope, and plow on up. Nothing so immediately tones that derrière than a swiftly ascending stroll. Our gluteus muscles, aka your butt, like nothing more than a good, soaring challenge. Your glutes are all about extending your legs backward, which is exactly what climbing does. So go for it, baby! What are you waiting for? Have mountain, will scale! Okay, if you live in the flats, like I did in middle America for so many years, you might have to settle for a treadmill. But crank that puppy up to a mean incline, and feel your booty kick some ass!

AFFIRM THE CURVE
(POSITIVELY SWEET-TALK YOURSELF)

*My body proportions
are just right
exactly as they are.
My body is a perfect
expression of me.*

BIG BOOBS, LITTLE BOOBS

I'LL KEEP MINE, THANK YOU VERY MUCH

"I was the first woman to burn my bra – it took the fire department four days to put it out."

– Dolly Parton, entertainer[28]

I was born flat chested and have remained that way all the way to this writing. I don't think anything is going to change.

Being small breasted has been interesting. It's had its up and downs, advantages and disadvantages. I've had two distinctly polarized experiences concerning my tiny breast situation. The first is of gratitude whenever I get to jump, bounce, and dance braless, staying perfectly carefree and burdenless. In fact, I've never owned a bona fide bra. (Training bras and sports bras don't count.) I've never had to deal with underwire, and I can feed many starving children in India with the money I've saved by not getting sucked into Victoria's Secret's gravitational force field.

The other side of the coin has to do with men. Each first time with each new guy, it was always the same. He would clumsily unbutton my shirt and make his way up to my chest as I practically held my breath until I was blue in the face. Why did he even have to bother? Couldn't he tell from the outside that I'm flat? Okay, let's just get it over with. I don't have big boobs! All right—I'm flat! Are you satisfied?!

Breast size has so many facets, connotations, and implications. While I would feel glad that I didn't have big breasts (because it falsely implied being a slut and lured in the wrong kind of boys), I would also feel incompetent as a woman for not providing my boyfriends with that all-powerful gift of big boobies. When I was young, I'd dreamily look at the girls with big chests, imagining that their boyfriends would never leave them due to their

Rachel's Rant:
My body is perfect just the way it is. It tells me so in many ways. It walks paths, dances fantasies, climbs mountains, lifts groceries, carries me through life, and always perfectly delivers me to my destination right on time. It eats, digests, eliminates, and reproduces, giving me energy, health, and family. Must mean my body is just right, as is, don't pass go, don't collect $200, no questions asked, end of subject.

ample endowment. What's funny about it, though, is that no boy or man ever had any problem with my body. It really all came from my own insecurities. I felt insufficient, like I was cheating them out of their due right as men. How could they ever be satisfied without a generous bounty of breast, I worried?

My first preoccupation with my not-so-burgeoning size happened with the insurgence of the bra-snapping sport that all boys engaged in right around fourth and fifth grade. It had to do with us poor, unsuspecting girls leaning over the water fountain and getting our bra straps snapped from behind as a lame form of semi-flirt, mostly torment, pseudo-communication from the boys. I was embarrassed because I didn't have a bra on most of the time, and if I did, it was some teeny-tiny training bra that obviously didn't "snap" as much as the other girls'. I became painfully self-conscious that my body already wasn't giving men as much pleasure as the other girls', even if it was only in the form of playing practical jokes on us.

A favorite memory from later in life was when a well-intentioned man thought he was doing me a favor by telling me, in the throes of a hot moment on my blue-velvet couch, "My mother always told me that more than a handful is a waste."

"Are you on crack?" I internally convulsed as I almost died of a massive, humiliation-induced cardiac arrest right then and there. Did he actually think that he was in the least bit convincing? Or was he trying to console me for what I formerly thought was an okay deal he was getting with my body, but was now convinced was a bargain-table compromise?

Perhaps men just cannot win with us women. Perhaps no matter what they say in regards to our bodies, if we are self-doubting, we will always hear through our insecurities, perverting even the most well-meaning comments into disastrous cuts to our egos.

A couple of years ago, I was skating down the beach in my bikini, and a man yelled out to me that I shouldn't be wearing a bikini top with such a flat chest. It floored me. I was shocked that anyone could be so mean and thoughtless. Then I, of course, looked down at my small breasts in my bikini top and insecurely

wondered if he were right. I was embarrassed and distressed enough to talk to a few friends about it, who all confirmed that I had no business believing him and that I should go right on with my bikini-clad skating, small breasts and all. I heeded their advice and have been happily sporting my itsy-bitsy, teeny-weeny breasts in bikini tops ever since.

That breast disclosure got taken to a whole different level when we shot the cover of this book. My designers wanted to eliminate as much airbrushing as possible, yet keep the pristine look of my body's curves. Plus, we had to make sure I wasn't naked in front of the twelve people in the studio all day. So they made a mad dash for Macy's on 34th Street and came back with flesh-colored, daisy-shaped pasties to cover my nipples.

My female editor came into the dressing room, handed me the little package, and assisted me in placing them correctly. Then came shock number one: She called in her male graphic design artist to okay them. I could have fainted, I felt so exposed, vulnerable, and under-endowed. He was as calming as a man could possibly be, taking a quick, nonchalant look and approving my coverage.

Shock number two came when I walked out into the studio for the first time. Pasties cover nipples; they aren't supposed to cover breasts. My breasts, however, were pretty much covered by these pasties. I felt like a pre-pubescent girl. It was funny, because there was a part of me that felt like since I have such small breasts I really didn't have anything to hide. Then there was another part of me that felt like I needed to hide the fact that I have such small breasts. Then there was a third part of me that shook me to my senses, remembering the title of the book I'd just written.

An hour into our nine-hour shoot, I forgot all about my breast size. It didn't matter.

REFLECTIONS

Booby-talk is an avid topic among women. It seems we always want—or at least think we want—something other than what we're endowed with. What a bummer. Here are our poor breasts, just wanting to be beautified, embellished,

and flattered, and instead we have regular pity parties and bitch sessions ragging on them. No fair.

Big, little, round, flat, perky, droopy, and uneven, breasts aren't cookie cutter. But if you're like me, you've had some lack of confidence at some point about your breasts. Solidarity. Yes, solidarity is my suggestion. Let's bond through our shared timidities. We've all got breast issues. I think it's part of the territory of being a woman.

CURVO QUOTES
(IN YOUR WORDS)

"*I LIKE MINE—BOTH OF THEM.*
AND THEY DON'T MATCH."

– Debbie, insurance broker

"*I had large breasts at age twelve.*
Nobody explained where they came from, and
I longed for the days when I played
basketball with the guys, without a shirt."

– SARK, author[29]

CURVO INFO
(JUST THE FACTS)

"Our cultural ideal is of a woman with a matched set of erect, eighteen-year-old breasts. This causes all those women who don't match this ideal (the vast majority) to feel that something is wrong with them. I wish that every woman could have an opportunity to know how truly diverse breast sizes and shapes are and could see how much they vary among women. They would then realize how skewed our perceptions normally are about our breasts. We'd have a chance to begin loving the breasts we have, instead of comparing them with an impossible ideal." – *Dr. Christiane Northrup, author*[30]

@ @ @

"Until a few years ago, the average American breast size was 34B. It has since changed to a 36C, due to the large amount of women that have had breast augmentation surgery and the fact that the American public is getting heavier."
– *Breastnotes.com*[31]

CELEBRITY CURVOLATION
(WHAT THE CELEBS SAY)

"I'M SO SCARED GIRLS LOOK AT [MY BREAST IMPLANTS] AND THINK, 'TO GET BOYS, YOU NEED BIG BOOBS.' I TELL THEM, 'DON'T GET IT DONE. THOSE FEARS GO AWAY. YOU DEVELOP OTHER INSECURITIES, BUT BREASTS AREN'T ONE OF THEM.' I WANT TO GET THEM HALF-SIZE." – Jenny McCarthy, model and actress[32]

"What's so beautiful about breasts is their uniqueness. I don't understand the obsession with fakeness. It's a very odd thing, isn't it, to prefer fake and big to small and unique or just beautiful and real." – Anne Heche, actress[33]

"I would never get implants, ever. I just got my chest in the past year, and I couldn't be happier because I used to be the flattest person ever, stuffing my bras. It scares me that older men would think about that."

– Lindsay Lohan, actress[34]

"WHEN I WAS YOUNGER I FELT LIKE, 'I'M FLAT-CHESTED? I'M SO EMBARRASSED!' I WORE PADDED BRAS UNTIL I WAS SEVENTEEN. NOW I DON'T CARE. I'M HAPPY TO BE SMALL. BUT BOY, [BACK THEN] I WOULDN'T LET ANYONE LOOK AT THEM, TOUCH THEM, NOTHING." – Paris Hilton, celebrity heiress[35]

"I do wish my breasts were bigger. Not big . . . but less small." – Calista Flockhart, actress[36]

CURVO QUERY
(ASK YOURSELF)

- Do I scrutinize the size of my breasts?

- Do I think I would be more of a woman with a different breast size?

- Do I ever feel over sexualized because of my breast size?

- Does my breast size ever cause me vulnerability or insecurity with my partner or lover?

- Do I falsely think my breasts are defective if they don't stand up alertly at attention?

CURVO TURBO
(TRY THIS CURVOLUTIONARY ACT)

Make a CurvOlutionary Commitment to wear your breasts with pride no matter what size. Do not subscribe to the idea that only certain styles and tops are allowable and flattering for certain body types. Wear what you want to wear. People have always told me that I can "get away with" wearing certain kinds of clothing because I just have that certain body type or personality. Phooey. Anyone can wear anything they dang well please! It's all a matter of letting yourself!

CURVOSIZE
(WHY EXERCISE WHEN YOU CAN CURVOSIZE?)

The CurvO Car Wash experience: think Jessica Simpson and her Dukes of Hazzard music video. Whichever part of your body is well endowed, breasts or booty, use them for all they're worth. Go on out and wash your car, and then find a big, plush, oversize towel, wrap it around your most sizable body parts (be it boobs or cheeks), and dry, baby, dry! That's right. You heard me. Use your chest (or booty, if more appropriate), swathed in terry cloth, to dry that car. Use what your mama gave you to get every last inch of that car squeaky clean and sparkly. You'll be finding ways to move and extend your body that will get your heart rate up, plus you'll most likely spy the neighbors peeking out from behind their drapes, wanting a part of the action.

AFFIRM THE CURVE
(POSITIVELY SWEET-TALK YOURSELF)

My breasts are just the right size for my perfect body.

I'M 37 YEARS OLD AND WEIGH 150 POUNDS
WHEN DOES A WOMAN EVER TELL YOU THAT?

"There are moments when I can't believe I'm as old as I am. But I feel better physically than I did ten years ago. I don't think, 'Oh God, I'm missing something.'"

– Madonna, entertainer[37]

"Man is the only creature who refuses to be what he is." – Albert Camus, philosopher[38]

W ho decided a woman is not supposed to have an age or a weight? And when did these numbers become obscene?

I've witnessed strangely curious behavior watching women squirm and blush their way out of revealing their numbers. You'd think someone had just asked them something truly embarrassing, like, "What's that huge black-and-blue splotch on your neck?" or "You really believed in Santa Claus?"

You know what I'm talking about. It happens every day of the year for someone—birthday time, a time to celebrate how many years of experience you've garnered on the planet. A day to commemorate your life's journey, the time you've spent traveling, living, and learning.

What is so blasphemous about asking the number of years my fellow explorer has logged onto her odometer?

I am fascinated with women's stats. I see all women as either my fellow travelers, wise elders, or possible apprentices. We are on the same team. We share the planet together. We walk through the same travails, the same aging process, the same struggles, triumphs, ecstasies, and agonies.

Rachel's Rant:
I know for a fact that women could love their bodies a whole lot more. Most women don't love their bodies at all, and this is a tragedy. That means that most women cannot even come close to their full potential of intimacy, for they are unable to bring their full selves to the table. That also means that most women cannot come close to their full potential sexually and orgasmically, for an unloved, unaccepted body cannot possibly reach its highest potential for pleasure.

Why must we hide our age and our vital statistics from each other? All women have them. And theirs are probably pretty similar to ours.

This number denial has deeply disturbed me for some time. Pretense is not one of my strong points. Never liked it, never will. Who else is there for me to be? When am I ever going to be this age again? And who else gets to be my

exact weight or configuration? I'm captivated by living my life right here, right now, at this very age and weight. This reminds me of a dance teacher that always instructs us to be more interested in ourselves. She tells us that if we are not interested in ourselves, probably nobody else will be either.

When we hide ourselves, how old we are, and how much we weigh, we deny our very reality. Our self-rejection says it is not okay to be who we are. We have no chance of ever being what we are "supposed" to be. We're always the wrong age or the wrong weight. We've always somehow just missed the boat to that perfect ideal. I've always felt a deep-seated pain when a woman denies or refuses to tell her age or shamefully rolls her eyes at the thought of her weight. It feels like the ultimate abandonment. It feels empty, hopeless, and futile.

As a fitness professional, I used to love the women who came to my classes. We would all gather at obscenely early morning hours to sweat together, stepping up and down on boxes, grapevining and pulling big rubber bands down from overhead. No matter what age and weight I was or what age and weight the women in class were, the constant cover-up and dissatisfaction with these statistics compelled me to take my best shot at making a difference.

I would create a festive buzz when our birthdays arrived, generating copious positive attention and telling everyone my age and how good it felt to finally reach that number, in turn giving them the opportunity to be out in the open with theirs.

I wanted other women to take my lead and be able to celebrate their accomplishments on the earth. If they were forty-three that year and had successfully birthed and reared two children . . . fantastic! Sing it out! Let us praise you!

It never quite worked that way.

Unfortunately, I found most women would sulk about another year and another birthday coming and going. They would usually avoid disclosing the precious number. And then they would go on to tell me that I was just too young to understand and that when I reached their age, I wouldn't be broadcasting such information.

This dynamic bred a fervor in me to hurry up and get to my prodigious year markers, so that I could prove to them how wrong they were. I rejoiced for months when I finally hit the thirty-year mark. At last! I had reached one of those pivotal years when most are bemoaning the end of their youth. I went around whooping and hollering, letting the world know.

And this is what I got: "Oh, well, wait till you're forty."

If things keep going like they are, you better look out, because forty is gonna be a knockout year. And fifty . . . off the charts!

I don't know if I can identify which number is more illegal, age or weight? I just figure it is best to publicize both, hoping to expose these secret topics for what they really are: simple factual data.

To some women you would think this data was a prison sentence.

Our vital statistical numbers are not our identity. They do not constitute anything more than indications and measurements. As the author SARK says, a woman should be measured by the size of her heart, not her thighs.

I actually get a big kick out of telling people my weight. It is such a revolutionary act these days. A proud reporting of one's weight elicits a confused response somewhere between shock and utter disbelief. You'd think I had just told them, in the middle of a formal social dinner with the Queen of England, how many orgasms I had had the night before.

People don't know quite how to react when I reveal my weight. An outright, uninhibited testimony of this number is just plain unheard of these days. That coveted number almost never sees the light of day.

I tell people my weight to dismantle the number myth. No one ever believes I weigh in at 150 pounds. They think only overweight women weigh that much. I am an attractive, athletic, healthy, vibrant woman. The number 150 doesn't match that picture in most people's minds.

I then, of course, can't help pulling out all the stops and telling them I am a size twelve. This one blows everyone's minds. In comparison to a model's size zero, size twelve seems like it must be for the obese. And there I am, a perky, early-morning mountain climber, yoga practitioner, and dancer sassily toting

my body in a size twelve pair of stretchy cords. And again the size and number paradigm falls to pieces.

The acceptable weight numbers we have become acclimated to are actually arbitrary standards chosen by insurance companies based on the "ideal" rather than average weights. They allow no age adjustments after twenty, instantly making obesity a huge and profitable problem. But there is conflicting research about the dangers of obesity. In fact, new scientific evidence points to the advantages of some extra weight in staving off cancers, while underweight people could be at a much higher risk for premature heart attack and stroke.

Studies show that being average or above average weight, in conjunction with moderate fitness, is the most beneficial recipe for health and longevity. This makes perfect sense. More cultures than not value a woman for her size and shiny hair. Both are indicators that she has enough body fat to be a fertile and able childbearer. In fact, in Nigeria, certain tribeswomen were actually fed cattle feed to fatten them up before their weddings. The thin women were looked down upon as sickly outcasts, who were either HIV-infected or dying.

Miss Nigeria never got more than local admiration until 2001, when the director of the beauty contest decided to go for an internationally competitive contestant. They chose an abnormally skinny woman, unfavored by her own people, but who went on to clinch Miss World. She became an immediate national hero, and the first instances of eating disorders in Nigeria were documented shortly thereafter.

One of my first volunteer jobs in L.A. was with Project Angel Food, delivering lunches to people dying of AIDS. I discovered all sorts of hidden streets and fascinating neighborhoods as I scouted out the addresses of those on my delivery route. I vividly remember walking up quaint, flower-decorated walkways and austere, depressing cinderblock paths to the doorways of these men. Most of them would instruct me to leave my package outside, too weak or sickly to open the door or entertain a stranger. But those that did answer were invariably emaciated. I stopped more than once to question my lifelong desire to be skinny. Seems being thin wasn't all it was cracked up to be.

THE SCALES OF INJUSTICE
(SLAVE TO THE SCALE)

"In the Middle Ages, they had guillotines, stretch racks, whips, and chains. Nowadays, we have a much more effective torture device called the bathroom scale." – Stephen Phillips[39]

I don't have a scale and I haven't for a solid eighteen years. The last memories I have of my former scale abuse occurred at my mother's house. I would head directly to her new-fangled digital scale each time I visited. For some reason it was strategically placed in the bathtub. Don't ask me why. I don't know if that was to get it out of the way of the more important things that go on in the bathroom, or hide it from my obsessive pursuit of its godlike status in my life at the time.

I was a budding thirteen-year-old whose sole pursuit in life was to get smaller. No more, no less. No matter what it might have seemed like from the outside, on the inside my priorities were not to be a good person, a strong dancer or athlete, a great writer, student, or do-gooder, a good daughter, sister, or friend. I didn't have any true passion for the arts, sports, literature, science, family, state, or religion. My entire faith resided in the scale.

In fact, not only did my complete self-worth come from that pesky restroom appliance, but so too did my daily barometer as to how I felt, what I was allowed to be, do, and eat, and how much exercise I was going to have to schedule and

Rachel's Rant:
This is what a scale is: a weighing machine. This is what a scale measures: level, size, balance, range, degree, extent, amount, magnitude, and dimension. Notice this list does not include happiness, self-esteem, worthiness, lovability, deservingness, goodness or badness, beauty, body image, fatness, distress, and sanity.

endure for the day. I also imbued the scale with some loftier powers, like deciding whether I deserved to go out that night and whether I earned the right to flirt. The illustrious number that scale assigned me also warranted or revoked my right to feel any semblance of happiness and, in my later years, decided whether or not I would be sexual that day with my boyfriend.

That gnarly contraption might as well have come equipped with a digitized voice that read out my daily horoscope and emotional forecast for the coming 24 hours. "You weigh in at a disgusting 152½ pounds today, Fattie. You get nothing today. Absolutely nothing. You might as well just go back to bed and pull the covers over your head, you lazy slob!" or "My, my, my, aren't you a good little girl? Look how small this number is! You've worked hard—you deserve a break today. You can take the day off from self-loathing and treachery and just enjoy the number 118. Good girl! You've made it!"

Depending on the day, this angelic or demonic appliance became my intrepid, all-inclusive judge and jury, sentencing me to bliss or doom in one fell swoop of its measuring device.

I remember trips to the doctor when I'd go through all sorts of discombobulations about whether or not I was going to look at those damn sliding measurements as they landed on my fate for the day. Like a sweating gambler playing a desperate round of roulette at a Vegas casino, I'd nervously twitch and fidget while the nurse slowly slid those worn, metallic game pieces back and forth. She was clueless as to what power lay in her mundane job of recording my vitals. How could she have known that she was single-handedly determining my value for the day, influencing my mood, and concluding my social status? Most of the time I would hold my breath and look away, hoping that I didn't happen to open my eyes just before she had cleared the beams of my appointed weight.

Scales are downright thieves. They pickpocket our happiness, sneaking it out the back door while we stare with glazed-over eyes at their mesmerizing readouts. The most inhumane thing about our favorite gadgets to hate is that they can turn a great day into a failure. Like a magic trick gone bad, a perfectly perky lady can

step onto a scale with a sense of optimism and a twinkle in her eye, and upon seeing an unfavorable number, step off laden with regret, doom, and despair.

Women have psychotic relationships with the scale, and I've become unwilling to participate in their madness. If someone is currently courting the scale, I opt out. I call it tough love. Like an addict practicing her compulsion, a woman in love/hate with her scale is a difficult person to deal with. She is prone to entirely irrational mood swings, temper tantrums, and fits of rage or glee, but mostly rage. She will fall into suicidal depressions by the scales' whims, but will defend her right to her appointed weigh-ins with her life.

Call me crazy, but after a couple dozen years of crashing and burning in despair every time I stepped on that dastardly device, I committed the radical act of throwing the thing out. And I've stuck with that daredevil stance ever since—no more scales for me. The craziest thing has resulted, something I would have never imagined: My body has stayed the same size without my Peeping Tom scale compulsion.

Imagine that. I am just fine, whether I consult the scale today or not. I no longer need a number to dictate my identity for the day. Freedom. Total freedom.

REFLECTIONS

Weight is good. Our living, pulsing, sensuous bodies are God-given. Our capable, thriving tissue mass is something to be proud of and to rejoice in. Our bodies serve as the only vehicle we were given for our precious ride through this thing called life.

Our age tells of the lessons we've invariably weathered, triumphs we've enjoyed, and world changes we've witnessed. I've always marveled at those epic *National Geographic* photos of deeply wrinkled Himalayan women high in the mountains. Their proud expressions teach me of the dignity inherent in earning the title of elder.

And so, it is with honor that I wear my age and weight and encourage the same for all others. Just air it out. Let the world know. Secrets don't feel good. Let the truth set you free.

CURVO QUOTES
(IN YOUR WORDS)

"I only tell people how old I am but never how much I weigh. That's private, and if they knew they wouldn't love me." – Ginnie, mortgage broker

"This man I dated told me that once I turned forty, my weight would balloon up and I wouldn't be able to lose it. As a result of being a good listener, almost immediately after my fortieth birthday I began gaining weight and have now kept an extra forty pounds on my body for the last seven years." – Janie, accountant

CURVO INFO
(JUST THE FACTS)

"Okay, what's going to happen as we age? If you're a woman, you lose estrogen and there's a shift in the activity of an enzyme called lipoprotein lipase (LPL). What does LPL do? It directs all this extra energy into fat cells, and so as you get older, as you get into menopause or after menopause, LPL activity gets higher in the abdominal region and your belt size gets a little bigger. And maybe the clothes that you could wear at thirty-five, even if you're the same weight, don't fit at fifty."
– *Dr. Judith S. Stern, author[40]*

@ @ @

The average American woman weighs 140 pounds, is five foot four, and a size twelve. The average American model, however, is 117 pounds, five foot eleven, and a size two. So, current models are seven inches taller, twenty-three pounds thinner, and eleven years younger than the average woman.

– *From womensissues.about.com, nationaleatingdisorders.org, and region.peel.on.ca.[41]*

☆

CELEBRITY CURVOLATION
(WHAT THE CELEBS SAY)

"WE'VE BEEN BRAINWASHED TO THINK THAT MEN AGE
BETTER THAN WOMEN. HONESTLY, I THINK I HAVE
A BETTER BODY NOW THAN I EVER DID."

– Andie MacDowell, actress[42]

"I know one day I'll be considered too old.
I think forty-year-old women actually look more
healthy and fit than some girls in their twenties.
I've met women who have way better bodies
in their forties because they've been working on
them for all these years." – Claudia Schiffer, model[43]

"It's a losing battle trying to keep the shape you
had in your twenties. You've got to kiss all that
sweet goodbye, or you'll be crazy. I don' t know
how I ever looked that way." – Raquel Welch, actress[44]

"THERE ARE ONLY THREE AGES FOR WOMEN
IN HOLLYWOOD—BABE, DISTRICT ATTORNEY,
AND 'DRIVING MISS DAISY.' " – Goldie Hawn, actress[45]

"I have everything I had twenty years ago-
except now it's all lower." – Gypsy Rose Lee, stripper[46]

CURVO QUERY
(ASK YOURSELF)

- Do I constantly deny my age and weight?

- Am I aware that my body hears every thought I have? And that mean, non-accepting thoughts are not nice at all?

- Do I falsely believe that my age and weight will deflect others from loving and accepting me?

- Do I actually believe that there is a right age and weight to be?

- Do I understand the nature of reality—that the only healthy and sensible way for the numbers to go is up?

CURVO TURBO
(TRY THIS CURVOLUTIONARY ACT)

Make a CurvOlutionary Commitment to telling people how old you are. Tell people how much you weigh. It's really fun and interesting to break through that whole weird anathema of keeping our vital statistics locked in secrecy. I've made it a habit, and men find it absolutely thrilling when women are out-and-out honest and open on these topics, instead of ashamed and secretive. I've also noticed a certain reaction of relief from other women, confirming that this is helpful for them to hear as well.

CURVOSIZE
(WHY EXERCISE WHEN YOU CAN CURVOSIZE?)

Want to feel vital at any age or weight? Yoga postures are great for making you feel young, invigorated, graceful, upright, and regal, the way a proud woman should. The ones I like—that reinforce a confident, upright posture and strong back—are sphinx, cobra, and Superman. So try out sphinx first: lying on your stomach, gently prop yourself up onto your elbows and forearms, pulling your chest forward and feeling your upper back lift. Next, with your palms flat

on the floor right next to your breasts, prop yourself up further into a strong, statuesque cobra by gently lifting through your back muscles and pushing up through your hands to gracefully arch your back. Next, to further strengthen all those stand-up-tall-and-proud muscles, lie on your belly and slowly lift your head, neck, chest, arms and legs off the ground like you are flying through the air Superman-style. Or perhaps Wonder Woman-style.

AFFIRM THE CURVE
(POSITIVELY SWEET-TALK YOURSELF)

I am proud of my years and my pounds. I live heartily and healthily, taking up the perfect number of years and the perfect amount of space.

GOT JEALOUSY?
WHEN HER PERFECT BODY IS KILLING YOU

"I have a boy's body. I would prefer to have more curves because I think that's more beautiful. I love curves! I'd much rather have J. Lo's body than mine." – Nicole Kidman, actress[47]

"My wife's jealousy is getting ridiculous. The other day she looked at my calendar and wanted to know who May was." – Rodney Dangerfield, comedian[48]

Have you ever been glad that no one can read your mind? Or that your thoughts are not audible? Have you ever thanked God that no one could hear the nasty litany of jealous jeers going through your head upon seeing one of those billboards or magazine covers with the picture-perfect model, or the woman going out with that really cute guy?

I've stood in line at the grocery store many times suffering ridiculous amounts of envy over another woman's body. I've caught myself blatantly wanting to have her body instead of mine, wishing that my body would miraculously change and being absolutely convinced that my life would be much better if I had her body.

Then those unrelenting thoughts will usually move on to some sort of jealousy-induced resentment at her for being so undeserving of that perfect body. I proceed to go into a full-on internal rage that she gets to have that body, and that I don't. I will make all sorts of snap decisions, based on a nanosecond's glance, about how she probably gets everything handed to her on a silver platter and that I've had to work so hard for everything in my life. And that she's not as good as I am anyway.

That's about the time when I get a bird's-eye view of my thinking

Rachel's Rant:

"If everybody looked the same, we'd get tired of lookin' at each other" are the lyrics to one of my favorite dance songs. I've always loved that song. Wanna know why? It's the truth. I know that we are all supposed to look different and be different sizes because we are. Byron Katie, author of Loving What Is, says it best: "When you argue with reality you lose—but only 100% of the time." She also says that we suffer when we choose to believe our rampant, harmful, unchecked thoughts. Thinking our bodies are wrong, ugly, or less than someone else's are very hurtful thoughts. They are also bogus thoughts. We did not choose these thoughts. They simply roam through our heads, and we choose to not only listen to them, but also define ourselves by them. And then we suffer.

and rejoice that my thoughts are only in my head and not being broadcast over the grocery store's PA system. I usually consider committing myself to some sort of anger-management program right about then as well. As the green-eyed monster's voice continues, I also realize how similar I am to many of the babbling street people I see talking out loud to themselves.

Phew. Jealousy is nasty stuff. It's prickly and thorny and ugly. It causes what seems to be a perfectly normal female specimen to turn into an envious, outraged, and flat-out defeated soul. Why are we so well equipped with such a flattening human skill? What evolutionary purpose does jealousy serve? Is there actually a good side to jealousy that, when practiced in moderation, enhances our experience of life? Or is it simply God's cruel joke on us? We are tempted by its treacherous lure and then eaten up and spat out, beaten and pathetic.

Jealousy is so embarrassing.

And our dearly beloved media capitalize on this weakness. Anna Nicole Smith's TRIMSPA billboard "Be envied" is a good one, don't you think? Pretty telling of our society's fascination with pain and suffering. "Don't hate me because I'm beautiful" is one of my favorites. Such blatant cashing-in on our most thwarting attribute. *"No, I don't want to waste my precious energy on hating you, bitch, because you are drop dead-gorgeous, okay? Not my favorite way to spend a sunny Sunday afternoon, festering like a rabid dog over your good looks and my mediocre appearance!"*

Jealousy is also bonding. It is something we can all relate to. It is a universal female experience. We can bond with one another in our mutual covetousness of another's gifts. That is probably one of the best ways women have of lying to themselves. They get into a virtual envy frenzy, disguised as a bitch session about some other woman's inadequacies. Everyone will join in as a weak attempt to make themselves feel better by putting someone else down, someone they secretly admire and would cut off their left breast to look just like.

This entry from my journal a few years back tells it all:

"I'm looking at her and either putting myself down in comparison to her or putting her down in comparison to me.

This is ugly. I don't want to admit it, but it's killing me. It makes me feel immobile, hard, stuck, and hideous inside when these thoughts are going through my head.

When I'm looking at her, that one with the big head of Ms. Curly-Q hair at dance class that has a different man each time I see her, I want to kill her. Her tiny body poured perfectly into her Hard Tail bootleg dance tights. I'm feeling so less than, so wild, untamed, and big. Too big. So naturally what I do in defense is scrutinize Ms. Curly-Q, scouring for all the reasons why she sucks. Certainly I can start feeling better if I put her down, can't I? So, I start with her body. I decide she's really not that sexy at all. Too thin. And that hair. It's gotta go. Too big. She relies on it for her beauty.

But, uh oh, no sooner has my scathing gaze moved away from Ms. Curly-Q than it lands on the long svelte lean gazelle gravity-defying one with gorgeous, all-natural features who dances like a modern ex-ballerina on Ecstasy. The beautiful blond who starred in her own TV show, who speaks eloquently and has a uniquely androgynous name, whose ex-boyfriend told me she has the most beautiful body he's ever seen. Screw her, too. She's way too skinny. And who cares about TV anyway? And she's really not all that pretty."

Exhausting. Utterly grueling, all this jealousy-fueled thrashing chitter-chatter.

And as for the ones I'm not jealous of, they do not interest me. They don't exist in my self-bashing world. I seem to be much more attracted to the ones I can hurt myself with. I am far more subversively allured to the ones I can beat myself up with, simply because I am not them. And, then, ironically, I rip them apart for not being as cool as I am.

Yuck!

My precious life-blood energy is seeping out of my veins like floodwater, betraying my own vitality for the promise of someone out there who's surely got more than I.

Wherever I go, it seems "she" is always there, too. She is cuter than I am.

Sexier than I am. A better dancer. She's got hipper clothes and a thinner shape. And I can't keep my eyes off of her. She becomes mesmerizing to me. Surely she gets more men, more attention. Whatever it is I want, she gets more of it than me. I've somehow convinced myself to believe, in a nanosecond, that she's living my fantasy life. And I render myself scarred, bruised, pummeled, wounded, bleeding, and dragging my emotional knuckles on the ground.

Oy vey! Stop the insanity! It's enough to make you nauseous, isn't it? But do we not experience these kinds of torturous feelings?

What are we supposed to do about jealousy? It seeps in at the most unwelcome times. Jealousy is a thief. It robs us of precious moments much better spent being in love with life than squandering away time with obsessively envious thoughts.

REFLECTIONS

We don't see people running around with "Got Jealousy?" T-shirts on, do we? Know why? It's no fun. It's not cool. And it's definitely not going anywhere unless we do something about it.

I've learned that the quickest way to losing really bad habits is to first tattle on myself. Ratting myself out seems to loosen up the grip. It lightens the load of the skeleton in my closet, turns on the lights, calls a spade a spade . . . and then, poof! Sooner than later, that monstrous, ugly fiend vanishes into thin air. Or at least turns into a silly joke of an ogre that no longer rules me.

CURVO QUOTES
(IN YOUR WORDS)

"I never looked like anyone else. I had rich, caramel-colored skin; gigantic brown eyes; and hair that had a curly mind of its own—yet my uniqueness was lost on me, for I wanted to be tall, thin, and blonde. When I was eleven years old, I'd pray extra hard that when I woke up in the

morning, I'd look like Barbie. Every morning I was disappointed . . . Katherine St. Claire's thighs didn't touch. When she walked, you could actually see space between her thighs. And she always had the newest Jordache or Sergio Valente jeans to accentuate her long legs and hug her tiny waist. She looked like a Barbie doll-tall and lean and every 11-year-old's idol (well, at least mine). But where I envied her most was in the way boys would talk about her. . . . I tell a tale we all can relate to, of not feeling comfortable in your own skin and always wanting to be someone else." – *Jessica Weiner, author*[49]

CURVO INFO
(JUST THE FACTS)

"We girls had been inseparable . . . our friendships completing each other, our reflections in the others' eyes making life whole. Now our mutual appraisals demanded that we judge one another through the eyes of the opposite sex. Suddenly boys were the judges, and we, unquestioning, lived by their scorecards; how they rated us made us see one another in a different light. . . . The irony for adolescent girls is that while we may desire our image in the boys' eyes, the judges who still rule life are The Other Girls, whose eyes are no less harsh, no more tolerant than mother's." – *Nancy Friday, author*[50]

CELEBRITY CURVOLATION
(WHAT THE CELEBS SAY)

"I was so skinny and gawky growing up. Kids called me Olive Oyl. I wasn't happy-I was

drinking Ensure to try to gain weight. You know, some people are overweight, others are thin. Either way, as a teen, you don't feel comfortable with your body." – Carolyn Murphy, actress[51]

CURVO QUERY
(ASK YOURSELF)

- ◉ Do I compare my body to other women's bodies too much?

- ◉ Do I ever feel truly good or happy comparing my body to others?

- ◉ Do I really believe that someone else's "perfect" body would make me happy?

- ◉ Jealous means feeling bitter and unhappy because of another's advantages, possessions, or luck. Do I really want to be that jealous person?

- ◉ Have I ever thought that jealousy just isn't worth it?

CURVO TURBO
(TRY THIS CURVOLUTIONARY ACT)

Make a CurvOlutionary Commitment to compliment a woman you might normally feel jealousy toward. My friend went up to a beautiful-legged woman at the zoo and complimented her, and the woman turned around and said, "I'd like to tell you that I work out, but it's all genetic." My friend was floored.

Befriend a really pretty woman whose looks you admire. I've found this to be absolutely eye-opening and freeing because the woman always turns out to be human just like me, full of the same insecurities and life challenges that we all have.

I've actually made it a goal to conquer my jealousies by diving right into the belly of the beast and befriending really gorgeous women. I particularly remember one aerobics instructor that was hated by all the rest because she

had such an incredibly muscular physique. I decided to offer her my friendship, as she was new at the gym and none of the other instructors wanted anything to do with her. She was so grateful for my kindness and later went on to relate to me that she oftentimes found herself alone because so many other women were threatened by her body and good looks.

CURVOSIZE
(WHY EXERCISE WHEN YOU CAN CURVOSIZE?)

Now invite that beautiful woman on a mall-shopping extravaganza! But make this an invigorating shopping experience, not a stagnant buying experience. Make a plan to get together with this woman and spend time moving swiftly about either a large indoor mall or outdoor boutique strip, aspiring to cover as much ground as possible. You can simply admire all of the lovely things, but not stop and buy. You will find out about each other's tastes and preferences, have things to talk about, and be moving right along the whole time.

AFFIRM THE CURVE
(POSITIVELY SWEET-TALK YOURSELF)

There is enough room for all of our beauty. I have a unique beauty and body that is appreciated.

TYRANNY OF THE MIRROR

WHEN ENOUGH IS ENOUGH IN THE LOOKING GLASS

"I used to look in the mirror and feel shame. I look in the mirror now, and I absolutely love myself." – Drew Barrymore, actress[52]

"I see my body as an instrument, rather than an ornament."

– Alanis Morissette, musician[53]

So everything was going great. I checked my look in the mirror. Perfect. Every hair in the right place. In fact, not only was I was having an incredibly good hair day, but it seemed I actually looked thin in my outfit. All my dimensions orchestrated perfectly with the cut of my skirt and tank top, leaving me irresistible and ready to hit the streets. Cool, confident, charged, and frisky, I set out to go wherever: run errands, go grocery shopping, pick up a couple of potions at the local overpriced toiletry shop. When all of a sudden, it happened. The dreaded next mirror appeared. I was doing fine, feeling good, happy, and confident. But then the lure of the mirror reeled me into its hex, and I started criticizing my poor application of mascara, the frumpy line of my clothes, and the wretched bulge of my stomach.

Rachel's Rant:
The media are stealing our happiness by making us look in the mirror, where we come up short by comparing and despairing. They show us only one body type, and we actually believe that that type is supreme and the sole look deserving of complete adulation. We continue to buy a damaged bill of goods that's got us spending $50 billion dollars a year on fake body-changing schemes. What we are seeing in the media doesn't even approximate reality. And we are, unfortunately, comparing ourselves to these unreal images in our mirrors and suffering. We are ready for something new: a media with images that support us in our happiness and many more happy reflections in the mirror.

Ever think perhaps the mirror wields an unruly amount of power over you? Perhaps its tyrannical, magnetic pull has ruined your day one time too many?

I just discovered the definition of a new term I never knew existed. This monstrous word is "dysmorphophobia." Its more literal and descriptive name is "body dysmorphic disorder." And my favorite breakdown of the word, just getting real and downright dirty, is: "imagined ugliness disorder."

How incredible that science has coined not one, but three terms, helping the overly self-obsessed validate their neurosis as truly disabling.

People suffering from body dysmorphic disorder, or good ol' BDD as it's known in academic circles, experience an extreme level of body-image disturbance, body dissatisfaction, self-consciousness, and preoccupation with their appearance in the mirror.

I uncontrollably laughed out loud when I came across this term in my research. Just shrieked. Guffawed. That kind of release and laughter that happens when you just immediately identify with such a revealing, embarrassing, human vulnerability exposed by a comedian. You know what I mean— like when comics crack the obligatory joke about holding farts in public or toilet water splashing back up on your rear.

Everyone laughs because it is such a universally hidden human experience. Taboo. Unspoken.

Well, I must say that my unearthing of this scientifically coined word has shed a whole new light on my incessant and oftentimes derogatory mirror-gazing. You know what I am talking about. The kind of mischievously irresistible sideways glances into the plate-glass storefront windows, one after the other, as you walk down the street. The insidious and almost desperate checking and rechecking of your look in each and every mirror down the hotel lobby hallway, bathroom, or clothing store.

The insane thing is that I've found these uncontrollable peeks can happen as little as sixty seconds after I've walked out of my house and away from the mirror that just told me (post hour-long grooming and preening) that I look killer hot for the evening. I walk out into the day or evening feeling like a gorgeous million bucks, carrying myself tall and proud. And then, invariably, from out of the blue, no matter where I go . . . there is that unasked-for mirror. Its tremendous gravitational pull reels my poor, unsuspecting ego into its reflective trance, and my negative voices start finding a little something wrong in practically every aspect of my look—from the trivial insecurity that my make-up application now looks terribly uncool out in the real world to the less-than-

anorexic way my waist looks under my sweater.

The most confounding thing about this torturous relationship with every mirror in the city is that I tend to look only at the one or two places on my body that I know will disappoint me. There are so many parts of me that will pass the myriad mirror stops. For instance, my arms, hands, feet, ankles, nose, forehead, and legs go completely unnoticed. But noooo . . . my quasi BDD won't let my poor, unprotected, innocent body get away that easily. Instead, it's straight to scrutinizing the very same inch that got criticized in the last mirror.

As if mere obsession with appearances and self-inspection weren't burden enough, now add into the equation that BDD implies that we are not even seeing the parts as they actually appear in real life. We are seeing them through our distorted thinking, which seeks only to prove its own faulty belief system: that something is wrong with us.

As a massage therapist, I tell people that if I could earn just a measly dime for the number of times people instantly grab their right trapezius muscle and put on a pathetic face of pseudo-pain the instant they learn my profession, I'd be rich. Likewise, my belly would be set for life if it earned even a penny for each time it weathered my angry, dissecting gaze in the mirror.

I'm not always kind to my body. And I suspect I'm not alone. In fact, I've witnessed firsthand, as a dance and fitness instructor, the evil, unforgiving sideways glances my peers shoot at their reflections in the mirror. They, too, seem to have their very own targeted parts. And their own bull's-eye areas probably feel just as defeated, vulnerable, and tired of being poked at, prodded, sucked in, and (mis)judged as my innocent belly.

Is it any wonder that the overly criticized parts of my body are the ones that give me the most trouble internally? I find no irony in the fact that just below the surface of my disparaged belly, an intestinal disorder has plagued my digestion for years.

I've found this principle to apply not only to body size, but also to any facet of self-scrutiny. I knew a beautifully dark-skinned black man who scorned his color due to a lifetime of discrimination and missed opportunities. He was angry and

withdrawn. He also suffered from a severe, insidious case of eczema. I asked him when it started, and he said right about the time of his adolescence when girls rejected him in favor of light-skinned boys. His skin loathing became so intense, he may have psychologically manifested a permanent skin condition.

Can we actually cause our own problems by aiming too much negative attention at certain parts of our bodies? Can the mere act of our own daily disapproval ignite troubling physical symptoms? I have no evidence to back up such implications. However, time and again I have seen the objects of my friends' contempt become problematic areas of their health.

I make a motion that we leave our bodies alone. Turn our backs to the mirror. Resist the often overwhelming temptation to cut our reflections down.

Let the mirror be lonely for a while. Let the mirror feel abandoned, just as we've abandoned our natural propensity to love our bodies.

Easier said than done. A lifetime habit doesn't die overnight. We all know that. I suggest a gentle approach to breaking this wild stallion of a habit that's thrived for so long in our daily behavior. One opportunity at a time, choose *yourself* instead of the mirror. Perhaps make it a game. Games are fun. You score each time you successfully make it past that devilishly tempting mirror without the slightest of glances.

In twelve-step programs, addictive behavior patterns are replaced with opposite actions. Something actually takes the place of the confounding conduct. Perhaps each unnecessary mirror-peeking temptation can be a brand-new trigger for you to take a deep, full, luxurious breath and feel yourself from the inside. Take inventory of how good your digestion, respiration, heart, and head feel. Take in some more oxygen instead of your reflection.

Your body needs you. The mirror can wait.

REFLECTIONS

Instead of "Mirror, mirror on the wall, who's the fairest of them all?" how about: "Lookie, lookie, I'm so fine, I look pretty all the time."

CURVO QUOTES
(IN YOUR WORDS)

"SOMETIMES, WHEN I AM GOING OUT ON A DATE AND I AM GETTING DRESSED, I LOOK IN THE MIRROR AND SAY OUT LOUD TO MYSELF 'THIS IS WHO I AM!' FOR SOME REASON, THAT REALLY HELPS ME FEEL CALM INSIDE AND REALIZE THAT OTHER PEOPLE CAN EITHER TAKE ME OR LEAVE ME, BUT THIS IS WHO I AM! IT IS VERY EMPOWERING FOR ME." – Jackie, restaurant owner

"I had a terrible shock today. I walked past a full-length mirror, and I looked so fat that I didn't even recognize myself! This isn't the way I see myself from the inside. It's like I'm in a stranger's body. Am I crazy or what?"

– Mimi, hairdresser

CURVO INFO
(JUST THE FACTS)

"Body dysmorphic disorder, or BDD, is thought to be a subtype of obsessive-compulsive disorder. It is not a variant of anorexia nervosa or bulimia nervosa. The person with BDD says, "I am so ugly." Sufferers are excessively concerned about appearance, in particular by perceived flaws of face, hair, and skin. They are convinced these flaws exist in spite of reassurances from friends and family members, who usually can see nothing to justify such intense worry and anxiety. They suffer from an extreme level of body-image disturbance, body-dissatisfaction, self-consciousness, and preoccupation with appearance and will experience the most negative reactions to the mirror." – ANRED.com[54]

@ @ @

"Your real body is the rich world of internal sensation and movement, the streaming currents of life force flowing through you. Your real body is not based on how you look and if you compete with the impossible ideals flaunted in magazines and on TV. Your real body is the tender touch of compassion toward yourself, no matter what's going on. This is your real body, not the one in the mirror." – *Camille Maurine, author*[55]

CELEBRITY CURVOLATION
(WHAT THE CELEBS SAY)

"Some days I would look at my reflection and see garbage, and I guess I was worried about the size of my breasts for a long time. But now I think I have finally reached an age where I have accepted myself for who I am."

– *Shakira, singer*[56]

CURVO QUERY
(ASK YOURSELF)

- Do I spend too much time looking at and scrutinizing myself in the mirror?

- Do I ever feel slave to the mirror, not wanting to look over and over again, but not being able to stop myself?

- Is the mirror my friend?

- Can I work on making the mirror my friend?

- Can I skip a couple of those extra times I glance in the mirror?

- Can I look at the parts I love a lot more when I look in the mirror?

- If I gave the mirror power, I can take it away, can't I?

CURVO TURBO
(TRY THIS CURVOLUTIONARY ACT)

Make a CurvOlutionary Commitment to boycott the mirror for one day. "Derive your sense of yourself from internal cues. Spend the whole day without looking in the mirror at any reflections of your body. See if you can shift your attention instead to the inner, subjective experience of your body: how it moves, how it feels, how it responds to the environment. At the end of the day, see if you have a different sense of your body." – *Marcia Germaine Hutchinson, author*[57]

CURVOSIZE
(WHY EXERCISE WHEN YOU CAN CURVOSIZE?)

Take your exercise outside the mirror-happy gym or aerobics studio and into nature, where you are smaller than every single tree, hill, mountain, and vista around. I found this to be the saving grace of my life after I quit my career as a fitness professional. It has been so healing to spend one or two hours mirror-free, climbing mountains and biking outside. I get to look at and be inspired by nature instead of scrutinizing myself in the mirror.

AFFIRM THE CURVE
(POSITIVELY SWEET-TALK YOURSELF)

I look just right all the time. My many looks are exciting and interesting and are what make me unique.

QUICK, POSE!

CONFESSIONS OF A TALENTED CONTORTIONIST

"I'll never forget it. A boy walked in the room, and I watched dumbfounded as Cheryl morphed, like something out of Kafka. Morphed from my bright, funny friend into this freaky, unexplainable Thing. When he came in, her voice got all slurred and babyish high, her eyes looked down, she started batting her lashes, she turned out her foot, and she sucked in her stomach and started giggling. I thought she was having a seizure; I almost called the paramedics." – Kathy Najimy, actress[58]

The gaggle of women lounged about, joking, lazing, hanging loose. At ease. Letting their hair down. Complacently enjoying camaraderie and comfort. From out of nowhere, in walked a man. Not just any man—a good-looking man. Suddenly waists were strategically twisted, chests pulled high, heads flirtatiously tilted just right, and all manner of primping and preening commenced. Involuntarily, each woman assumed The Position, gracefully standing at attention for the viewing pleasure of this innocent male. The game was on.

Women can act in the darndest ways. It's funny—the silly, sometimes demeaning, and oftentimes inconvenient ways women posture and pose to look like they are supposed to in order to win the man. The media have infiltrated and informed our consciousness to the point that we gratuitously sacrifice form, function, and comfort for that coveted appearance of sexy.

I learned a valuable lesson in this one day in massage therapy school. We were in an anatomy class, and a guest instructor brought in a slide show for us. One of the most poignant points he made started when he showed us a number of magazine ads of supermodels. He asked us if we saw anything peculiar in the ads. Being very desensitized to such images, we all looked at each other and shrugged our shoulders, having no idea what he was talking about. They were all photos of models doing the normal contortionist circus tricks, making their bodies look ways that our eyes have been trained to admire. They were

Rachel's Rant:

Incessantly trying to change our bodies is a losing game, a futile game, and a waste of time. We squander our precious energy in a useless attempt to achieve Britney, Christina, or Calista's body. Why try to change an apple to an orange or a dog to a cat? You can yell at the dog all day long to be a cat, but at the end of the day, the dog is still the dog. And besides, why would we want to be anything but our own glorious selves anyway?

twisted and turned to make their shoulders look broad while their waists looked tiny, one leg bent, the other hip sticking out, one side propped up, and the other dropped down—the usual model fare. We thought nothing of it.

He then asked us to show how that model, posed in that position, would actually walk. Everyone was too shy to respond, so he boldly got off his podium and started walking like a limping Elephant Man. We all got the point immediately. If her proportions were actually like the ones the picture was portraying, the model would have one leg way longer than the other, entirely uneven hip heights, and protruding ribs and breasts that would challenge any biped to walk.

But we've been hypnotized by the media. We will arrange and rearrange ourselves endlessly, positioning parts in just the right place to try and look just the right amount of prefab feminine. Problem is, our bodies aren't built like that, and sooner or later the charades are going to fail and someone is going to find out what we look like full frontal.

I can't tell you how many times I've displayed and then redisplayed myself to look spellbinding for my date when he returns from the restaurant bathroom. We've all done it, right? I've actually laughed out loud at myself. I will cross my legs one way and then the other, twist and adjust my torso, prop and then unprop an elbow, all in an attempt to seem gracefully carefree. Carefree. Yeah, right. Even better is the much-calculated standing up and elegantly sauntering to the bathroom while he is watching. This is no easy feat. There are many choices to be made at this point. Do I stand up straight-on or opt for the slight diagonal twist to the side as I exit the table? And at what point do I let him see my rear-end—before or after I've straightened my skirt and made sure to position myself as attractively as possible?

Another good example of this peculiar behavior comes when standing face-to-face with a man in full daylight. Do I just take a horse stance, with arms straight down to my sides? No way! Gotta do something coy and constructive with my arms and legs. After all, I do have all of these joints to organize—elbow, hip, and knee angles are all part of the secret flirty- flirt that goes on.

A little bend here, a little torque there, a little sway back there, and everything starts to get a lot more interesting. So therein starts the organization and reorganization of all the girly parts, as we aim for an optimally attractive body.

Only problem is I catch myself feeling like a fool, still playing these posing games for boys. Come on, Rachel, he's gotta know that you can't possibly look like this all of the time. Who in the hell am I fooling? Is he actually falling for this? After a certain amount of time dilly-dallying around with my posture, I usually stop myself, give it up, and just stand at ease.

I have a hilarious poster in my kitchen from About-Face, an organization that educates women on the damaging ways ads influence our behavior. The poster depicts a circus wagon in the style of the old Animal Cracker box, and inside the prison-like poles are various models in distorted poses, imitating circus animals. They are all strategically knotted into shapes that no regular human being would even want to attain. Their crooked, lounging bodies all defy gravity. The poster reads, "Please don't feed the models."

We might fool ourselves into thinking we've dismissed the models as impossibly bent into twisty shapes that we couldn't care less about. But then, here comes the guy walking down the street or into the bedroom, and there we are trying to remember how that model tilted her pelvis and chest just right to get that effortlessly waiflike effect.

Speaking of the bedroom, I always remember a conversation I had with a girlfriend who had just returned from the romantic adventure of her life in Paris with her new French boyfriend. They made love often, and she recalled him laughing tenderly at her for the way in which she "posed and performed" for him when she was on top. He said that Americans are way too concerned with how we look on the outside, as opposed to how we feel on the inside. He told her to stop being so nervous about how she looked and to just enjoy. He didn't want her trying to hold her body in a certain "attractive" manner to try and please him. He thought it strangely unnatural how we're so caught up in trying to look certain ways.

This made me think. A lot. I thought about all the ways in which our very

visual culture permeates our psyche, training us as to what even the most intimate acts and body parts should look like. We cannot help it. No matter how hard we may try to shield ourselves from these images, we are swimming in an aquarium of this self-conscious water. We exist inside this eye-centric atmosphere. We see images of perfectly posed models riding a man on the porn video cover and think that is how we are expected to look in the height of sexual ecstasy. These particular images have so haunted me, that I actually shy away from this showboat position for fear of not living up to these designer sex looks.

How am I supposed to look like one of those frozen, perfectly plastic pictures when I get out of bed to go to the bathroom, knowing full well that my rear-end will have to be dead center at some point unless I walk diagonally toward the door?

And, I have to admit, as pitiable as it is, I've actually tried to artificially make myself have cleavage in bed with a man by sort of purposely squeezing one arm in really close to my torso to push my tiny boob inward, trying to fashion a real breast-sized breast. You know you're in trouble when you resort to such feeble tactics.

So, thank goodness for growing up and just getting sick of trying to do things that take up unnecessary amounts of energy. They say that once a woman's had a child, she's been seen in so many unflattering positions that all modesty and body consciousness leave. I've not yet had a child and don't feel that is a good enough reason to have one, although I wouldn't mind that particular benefit.

REFLECTIONS

I've decided that natural is as good as it gets when men approach. I figure they are going to find out sooner or later what my belly and hips really look like. Might as well let them in on the truth now and spare myself any more useless contorting. It's so much more freeing to simply be the size and shape I am, rather than endlessly twisting and turning like carnival taffy for that perfect angle that vanishes as soon as their vantage point changes.

Nope, no more circus tricks for this girl. What you see is what you get.

CURVO QUOTES
(IN YOUR WORDS)

"I would suck in my stomach, cock my hips out, lift my breasts higher, tilt my head in a certain direction, and basically stop breathing! I remember getting stomachaches from trying to "hold it all in." Now, I am more comfortable in my body. I don't wear things that don't feel good on me. I don't disrespect myself by wearing things that don't honor me or make me feel good when wearing them. I affirm in myself, especially when a man does not look my way, that I am an amazing woman with tons to offer, and if he's only looking at my outside and that doesn't entice him, his loss." – Nora, film producer

CURVO INFO
(JUST THE FACTS)

"Three basic techniques used to establish superiority or power are size, attention, and positioning. People in charge of their own lives typically stand up straight, alert and ready to meet the world. In contrast, the bending of the body conveys unpreparedness and submissiveness." – *about-face.org*[59]

@ @ @

"Dismemberment or body-chopping in ads occurs more frequently for women than men. Women's bodies without heads, faces, or feet lead us to believe that all that truly matters about a woman lies between her neck and her knees." – *about-face.org*[60]

@ @ @

"Ads never let us forget that a woman's worth is determined by her appeal to men. Nothing else about her matters—not her thoughts, feelings, or experiences. She is an object to be judged, evaluated, and deemed desirable enough by the observer. Her only power lies in controlling and manipulating her appearance, and even then she is set up to fall short of the perfect ideal." – *about-face.org*[61]

CELEBRITY CURVOLATION
(WHAT THE CELEBS SAY)

"JUST STANDING AROUND LOOKING BEAUTIFUL IS SO BORING, REALLY BORING." – Michelle Pfeiffer, actress[62]

CURVO QUERY
(ASK YOURSELF)

- ◎ Do I "pose" too often to try to look right or get attention?
- ◎ Do I actually think people don't know when I'm posing?
- ◎ Do I think I must always be poised and pretty to be attractive and loved?
- ◎ Do I ever let my guard down and just be me, no matter what it looks like?

CURVO TURBO
(TRY THIS CURVOLUTIONARY ACT)

Make a Curvolutionary Commitment to stand tall and proud around others. Stand full frontal. Be strong, postured, and natural. People always comment that they like my posture, how I stand. I tell them that I love posture. I love feeling my body confident and well built, rooted in the ground and taking up space. I feel like a statue when I stand. Resolute. Firm. Powerful. Unapologetic. Try it. It feels awesome.

CURVOSIZE
(WHY EXERCISE WHEN YOU CAN CURVOSIZE?)

Strike a pose! Pick ten to fifteen of your favorite ways to pose—be they coy, demure, or dramatic—and hold them for thirty seconds each, flexing every muscle in your body. You better work it, girl! You will be very surprised at the power of isometric contraction. Feel your muscles burn as they labor to hold that stance.

AFFIRM THE CURVE
(POSITIVELY SWEET-TALK YOURSELF)

I am attractive and inviting just as I am.

DO REAL MEN LOVE CURVES?

CURVES ARE A GIRL'S BEST FRIEND

"All women have the potential to be sexy and it's nothing to do with the dress someone wears or the makeup they put on their face."

– Colin Farrell, actor[63]

"Back when I was young, the women were so much of curves," Heda, my sixty-two-year-old, early-morning hiking partner says as he sweeps the air in front of him in the shape of a massive torso's hind end. In his mingled Indian, Persian, and English slang, he tells me the same thing he's told me so many times before: There was a time, not so long ago, within his very own lifetime, when women were admired, coveted even, for their generous curves.

"I'll never forget how excited I was as a little boy seeing the black and white photographs of women's curvaceous bodies. I thought how much I wanted a woman like that. What's with these sticks, these matchstick women, these twiggy women today? Back when I was young, we looked at these women like they were sick. Something was wrong with them."

Heda is a virile, hearty, bright-eyed, forever-joke-telling ex-champion bodybuilder who owns a GNC nutrition shop. He goes on to tell me that the majority of his female customers

Rachel's Rant:

Men don't dig overly skinny chicks that obsess about their bodies twenty-four/seven. They also don't dig real-bodied women that don't love their bodies. Men love women who love their bodies. Men wish women loved their bodies more. Men want just for once to get to compliment a woman on her body and witness her receiving and taking in that praise.

Men love curves. If truth be told, my curves have been completely embraced and coveted by every man I've ever been with. No exception. They all just wanted me to be comfortable with my body. Throughout my lifetime, I have unofficially and casually (yet persistently) polled every man I could as to whether he liked a woman with a healthy amount of flesh on her bones. Across the board, every single one of them replied with gusto that they love a woman of healthy size. Not only was their reply hearty and passionate, but it was also accompanied by many excited gesticulations, enthusiastic smirks, and devilish grins.

are skinny women who are always sick and looking for supplements to help them. He doesn't see heavier women in his store nearly as much as the ultra-thin, desperately seeking the next panacea to their unending parade of ailments. He correlates their weaknesses to their slight composition and compromised dietary intake. Always looking for fat-burners, they are literally torching the life and health right out of themselves.

Why are women so eagerly, gratuitously, and voluntarily killing themselves to be thin? Do we really think this makes us look more attractive in the eyes of men? Yes, these "twiggies" are thin. It's one thing to be naturally thin and lithe. But when we force ourselves into that mold, it's another situation altogether. Sickly, weak, imbalanced, and weight-obsessed are not very attractive attributes to most men I've questioned.

The truth is that we are not even doing it to look attractive in the eyes of men anymore. Most women I know have boyfriends that ask them to stay the same or even gain weight.

As a healthy, fit, size-twelve, 150-pound woman, I've pleased the eyes, hands, and bodies of every man I've ever been with. I've never had a single man comment negatively on the voluptuous size of my body. The only person who continually comments negatively on the size of my body is me.

Heterosexual men don't want to be with another man. They want to be with a woman. Men biologically tend toward leanness and muscularity. Opposites attract. The differences between the genders are what make us so alluring to each other. The last thing men want in a woman is their own physique. Men are as enamored of our curves as we are of their broad shoulders, brawny chests, and strong arms. Vive la difference.

Here are just a few of my own personal "Real Men" accounts that proved to me, beyond a shadow of a doubt, that curves are indeed a girl's best friend:

> **Pat**—this man tracked me down after seeing me dance like a wild woman at an outdoor concert. He came up to me, asked me out for a cup of coffee, and proceeded to tell me how endearing my

belly was. He always made sure to touch it at least once each time we dated.

Lou—spotted me at a club, came up to me, and asked if he could kiss my belly. I obliged him. How could I not? He did it. It felt good. He asked for my number. Again, I obliged him. How could I not? He called the next day, and we dated for four months. He kissed my belly at least once every time we met.

Eddie—infatuated with the curves of my tushee. He couldn't keep his hands off.

Owen—fascinated with the strength of my sizably muscular legs. He always wanted to look at them, touch them, and admire them.

I've had boyfriends on their knees in love with me and my body, while I self-loathingly cursed my every curve secretly in the mirror. Their adoration and professions of love for my body slid off my impenetrable, self-defeating ego like beads of water off a car's waxed surface. My friend Danny told me that oftentimes, although highly attracted to full-bodied women, he's had a hard time connecting with them because they were so "tripped out about their bodies." He told me that both the media's and women's attitudes toward their bodies really affect him as a man. "I always feel like women that are bigger are tough because they are so uncomfortable with their bodies."

This same conversation led to the perplexing conundrum existing between what real men want versus what they might go for. He told me, "If I even went for someone with a little more body to her, I'd get shit for it. If she wasn't perfectly skinny, I was made to feel ashamed for going for the 'fat' one." Is it possible that men fall prey to the media's influence against their will, just like we do? "There's such an issue of other people's opinions and how you're looked upon as a man. Are you a stud? And it's based on the woman you have." He went on to say, "It makes you want to be with the skinny chick, like a trophy, just to show you're a stud—even though it's not your preference. I think some

guys are fooled: They start to think that's what they're attracted to, but it's not inherently true."

He went on to tell me that he's always loved the more voluptuous parts of women, and that he believes every man naturally does, too. The very parts of us that men like the most tend to be the parts that we fight the hardest. Men love the parts of us that are different from them. They like our breasts, bellies, hips, and behinds for their fertile broadness and fleshiness. We, instead, berate these essentially feminine attributes.

Self-loathing of our female body parts has become an epidemic. It is pedestrian and expected. These body wars are damaging not only to our self-esteem, but also to our creative minds and productive abilities on a greater societal level. Tests have shown that women perform markedly poorer on math tests after viewing photos of "ideal" bodies in revealing clothing. Women's preoccupation with this painful struggle to achieve impossible standards of beauty has devastating effects on their ability to think clearly and be productive.

I see this as a tragic misuse of the highly creative female spirit that has held men's attention captive throughout the ages. Women—through their finely honed, body-based intuition and wisdom—have been revered throughout history as benevolent leaders, wise elders, and sage healers. Our wombs are the seat of procreation, the most profound of all human creativity. We produce the eggs of life and contain the ability to grow new intelligence on the planet. Our generous hips were ingeniously designed to gracefully give way to the birth of our offspring.

By starving away our bellies and hips, we denigrate our very existence. By negating our abdomen, our core, we trespass the highest form of wisdom held by humankind. There is no more knowing place than our bellies, where life is spawned. And women are the chosen gender imbued with this precious, life-bearing gift.

The breasts, the belly, the hips, and behinds are the mysterious places men most want to visit. Get this—we've got something they don't have! And that's cool, way cool! Celebrate them! Wear them out loud! Be proud of the softness that ushers our femininity into the world.

I can see Heda now, in full bravado, as we descend down along the zigzagging canyon trail, passionately gesticulating as he continues his description of the pleasures he had as a young man, pursuing the juicy females of the time. "All those women, so much of curves," he vividly expresses with his hands, outlining their waists and hips in the fresh mountain air.

Ah, yes, let's imagine the day again when we give the world exactly what it wants . . . our full, healthy bodies—joyous, generous, feminine.

REFLECTIONS

Change is imperative. A massive schematic shift in how women see their bodies is needed now. If we're so convinced that men are the ones who created this new, thin ideal, then perhaps it's time to open up not only our ears but also our minds to hear what real men have to tell us. I guarantee that if you ask any admirable, healthy, respectable man what he most loves about the feel of a woman, you will be surprised to find how much he values the very feminine softness we are so heartbreakingly trying to extinguish.

Unfortunately, a man's opinion might not prove effective enough to blast through our strongly held insecurities. Our dark sides are invested in keeping us imprisoned within our flagging self-confidence. In turn we habitually hold on to negative body image for dear life.

At this point, I am convinced we are doing it to ourselves. Women don't even need anyone else anymore to tell us our bodies are wrong. We've so strongly internalized this message of being the incorrect size that we do it entirely to ourselves. And we do it voluntarily.

We have become our own police, our own censors, and our own worst enemies.

Stop it! Stop it now!

We need to love our very own curves so that men get the distinct privilege of loving them, too.

CURVO QUOTES
(IN YOUR WORDS)

"I AM A SCULPTOR AND HAD A MODEL WHO WAS A LITTLE HEAVY, WITH BEAUTIFUL CURVES AND FOLDS. I ADDED EVEN MORE TO THE SCULPTURE TO EMPHASIZE THE BEAUTY OF THE CURVES. I WANTED TO SHOW HOW BEAUTIFUL WOMEN REALLY ARE AND THAT THE MOST APPEALING THING IS REALLY THE DIFFERENCE FROM MEN, WHO ARE COMPOSED OF ANGLES AND STRAIGHT LINES, NOT CURVES.

I GOT TO WATCH THE ART PATRONS AS THEY WERE VIEWING THE WORK IN THE SHOW, AND THE MEN ESPECIALLY LIKED THIS PIECE AND WENT OUT OF THEIR WAY TO COMMENT ON IT TO ME. THEY ESPECIALLY LIKED HER ABUNDANT CURVES, WHICH SYMBOLIZED A 'REAL WOMAN' TO THEM." – Cinthia, sculptor

"I do think that men love curves and have been told that a few times, but it has not reached my heart to really take that in and believe it. My last lover told me (only when I asked him) that he liked my voluptuous body, but I never quite believed him."
– Joanie, aesthetician

"My grandmother said if I wanted to get married, I better learn to camouflage my body cause no one would love me the size I am."
– Genoveve, sales associate

CURVO INFO
(JUST THE FACTS)

According to the Australian news site www.news.com.au[64], men like curves. A survey has found that men with fuller-figured partners are less likely to stray than those with slim partners. It was found that 70 percent of men who remain faithful prefer women who are a size sixteen or larger. Only 20 percent of men with partners size twelve or larger admitted to cheating compared with 64 percent of men whose partners were smaller. Men with bigger partners were also more likely to describe their sex life as 'fantastic and uninhibited.'

CURVO QUOTES[65]
(IN HIS WORDS)

"A WOMAN'S SIZE IS SECONDARY TO HER KINDNESS AND SENSE OF HUMOR. YOU KNOW, IF WE WERE ALL SATISFIED WITH OUR BODIES AND LIFE CIRCUMSTANCES, OUR ECONOMY WOULD INSTANTLY SELF DESTRUCT." – Stan

"I don't understand this perceived connection between skinny and beautiful. Marilyn wasn't skinny. Mae West wasn't skinny. Yet they were each considered the sexiest women of their respective generations." – Eric

"I'M FIRMLY IN THE CURVY CAMP! I DO FEEL FOR THE LADIES OUT THERE. THERE IS A LOT OF PRESSURE FROM THEIR MOTHERS, THEIR FATHERS, THEIR PEERS AND THE FASHION INDUSTRY, ETC., TO LOOK SCRAWNY. REBEL, I SAY, LADIES! LIVE LARGE!" – Curt

"A VERY MALE-DOMINATED MESSAGE BOARD THAT I SOMETIMES FREQUENT POSED THE QUESTION AS TO WHAT FEMALE BODY TYPE WE FIND MOST ATTRACTIVE. NOT SURPRISINGLY, FULL-FIGURED WON A DOMINATING VICTORY, WITH SKINNY TAKING LAST PLACE BY A CONSIDERABLE MARGIN." – Dustin

"As a single man with a healthy regard for women, I have to say that personality is at least as important to a woman's attractiveness as body size and shape. An honest, friendly smile makes a huge difference." – Michael

". . . COMPLAINING OR HAVING ISSUES WITH YOUR BODY—ENDLESSLY—IS EXTREMELY TIRING AND EVENTUALLY THOSE PEOPLE HAVE DRIFTED OUT OF MY LIFE.'" – Matthew

"A girl can get a long way with a great attitude and carrying herself like she doesn't give a f*** if she doesn't look like a model. Confidence is one of the sexiest weapons a girl has on her side, not complaints about 7 grams of fat in the wrong place." – Gino

CURVO QUERY
(ASK YOURSELF)

- Do I believe in and acknowledge compliments on my body and looks, or do I always disregard, deny, or belittle the praise?

- Do I put down my softer female attributes by comparing them to leaner masculine traits?

- Do I date men who put down my body? If so, why?

- Has a man ever made negative comments about my body? Did I believe him? Why?!

- Have I ever considered what a gift my unique, feminine body is in contrast to the male body?

CURVO TURBO
(TRY THIS CURVOLUTIONARY ACT)

Make a CurvOutionary Commitment to let yourself be soft to a man. They love it. Know that they love to feel your curves as much as you love to feel their strong, broad arms and chests.

CURVOSIZE
(WHY EXERCISE WHEN YOU CAN CURVOSIZE?)

Wanna get fit and enhance your most attractive attributes to a man at the same time? Dance! What about taking a sensuous belly-dancing class? You'll feel sexy, move your midsection, and drive him wild. Or perhaps a fiery flamenco class? You'll get those legs stompin' and learn confidence to die for. Or what about a fierce tango or salsa class? You'll be getting fit and learning how to move those sexy hips and bellies in intoxicating ways.

AFFIRM THE CURVE
(POSITIVELY SWEET-TALK YOURSELF)

My curves are attractive and inviting to men.

HEY, HEY, SHE'S A BIG-BONED GAL

PSSST...NEVER CALL A WOMAN B-I-G!

"Bodacious is a great word. Curvaceous is my favorite, I guess. Plus-size is my least favorite. It's like you're outside the norm. But millions and millions of women in this country are!" – Queen Latifah, entertainer[66]

"I like big women," he said to me, thinking it was a compliment.

My mind, of course, took this as an opportunity to first defend myself against the comment, thinking, "I'm not that big," and then as a shooting gallery, pummeling myself with doubt and self-hatred for not being small.

A cute grin is all that came out in response to his innocent remark. The torrent of dangerous internal reaction to his word "big" was something I thought best to keep to myself. Did he really think I would want to be categorized as big by him? Didn't he know to never, ever, under any circumstances, call a woman big? What was wrong with him?

Rachel's Rant:
I know for a fact that women are supposed to have curves, or else we wouldn't. Why else would my body always want to sprout a little extra hip, rear, and belly action if not for the driving call of nature? I can confidently say that my body has a thriving life force that yearns to express itself with some luscious flesh. I have never been or felt more vibrant, strong, flexible, passionate, or sexy. Beauty is not a size, and I am living proof.

What was wrong with *me* was the real question that eventually surfaced. The word "big" inherently has no value whatsoever. It has no innate charge. It is not positive or negative. It is not good or bad. It is simply a quantitative word. An adjective. No more meant to set off an alarm or detonate a bomb than simply commenting on a tree. As in, "My, that's a big tree." Now, I would have absolutely no reaction to that, right? It's simply the truth. The tree is big. I seriously doubt the tree started having any sort of identity crisis, wondering if it was too big or exactly what we meant by calling it big.

Since when did being big become bad and being small become wonderful? Where did this pivotal judgment in worth come from?

And the body parts that are allowed to be big versus small are so arbitrary. So, I'm endowed if I have big eyes, lips, and boobs, but screwed if I have a big

nose, legs, belly, and arms? I'm supposed to have a big heart but a small belly? Who said so?

Another man, thinking he was charming by paying me the compliment of a lifetime while gawking at my legs, said, "I like a stocky woman." I felt like a heifer at a county fair! Was I supposed to feel sexy?! *"He must mean muscular by that word. Surely he means muscular—he's just verbally challenged,"* I desperately reasoned.

I can remember going to countless movies in my childhood and early girlhood, missing entire plot developments because I was so fixated on the tininess of the main heroine and other female characters. How did they get so small? I would seriously miss dialogue, so transfixed by their size. I figured since all the female leads on the screen were much, much smaller than me—and they got the gorgeous movie star men both on and off screen, while I didn't—then surely smallness was the answer to my dreams of being lovable.

I then walked the days of my life wishing like mad that I could be small so that I could possess the glory of the starlets. Somehow their magically small size became my false god, like the statues to the Romans. I worshipped smallness, bestowing it with all sorts of lovable properties. And, I didn't have it. I was the biggest of the cheerleaders, at an astounding five foot six and weighing in at a whopping, what, maybe 120 pounds maximum.

What I'm trying to say is that the brainwashing occurs regardless of what one's own reality is. It wouldn't have mattered if I were way bigger or way smaller than I was. I probably would have wanted to be something else. I probably would have thought that some other physical stature and sizing was the elusive key to my happiness. The proverbial carrot of smallness was always in front of my face, coaxing me to falsely believe my contentment lay somewhere outside of the parameters of my natural size.

I have a six-foot, drop-dead-gorgeous actress friend whose personality is bigger than life. She is an artist extraordinaire, completely outspoken, dramatic, graceful, artful, and fully unique. One day we were talking about her

troubled relationships with men, and I sympathetically said that she is so big and that intimidates men. I was referring to the bigness of her personality, her energy, her style, and her charisma. But all she heard was the word "big" and instantly became extremely self-conscious and vulnerable, asking me if I meant that, God forbid, her body size was too big.

How many times have you heard a woman cut herself down, saying frantically "I look so big"? What the hell is wrong with being big? And who decided what is big and what is normal and what is small? And why is it such a cardinal sin to be a larger size anyway? You would think it makes more of us to reckon with, more to love.

Why is it that a beer is coveted for being full-bodied, but women are punished? In k.d. lang's song "Big-Boned Gal,"[67] the lyrics joyfully describe a strong, voluptuous, lively woman:

> *"She was a big boned gal from Southern Alberta,*
> *now you just couldn't call her small . . .*
> *You can bet every Saturday night she'd be headin'*
> *for the Legion Hall*
> *When the big-boned gal came a'shufflin' in,*
> *she'd hold them in a trance . . .*
> *She walked with grace as she entered the place,*
> *yeah the big-boned gal was proud*
> *Hey hey, the big-boned gal*
> *Ain't no doubt she's a natural*
> *Shakin' and a snakin' and a steppin' out across the floor*
> *Reelin' and a rockin' and she's yellin' out for more"*

When I first heard this song, I was struck by the celebration of this large woman. I loved feeling how robust and full of life she was. And it made me think about many of our treasured female blues and gospel singers with voices that can move mountains and bodies big enough to contain their immense spirits.

A certain amount of mass makes a person more substantial. We label kids as not being tough because they are small, making them easy targets for bullies. We know that mother cats and dogs oftentimes overlook the runt kittens and puppies. We know that feeble newborn birds are more vulnerable to predators. Being small is actually a deficit in some situations.

Having some size means strength. Why do we put ourselves down for having fortitude? It's an attribute and valued by many cultures. In Fiji, women have always been revered for their thick, heavy strength. The bigger their calves the better, as they were signs of vigor. That is, until the year 1995 when Western television entered their world along with the show *Beverly Hills 90210*. That year was the first time the residents of this idyllic South Pacific island experienced body discontentment and eating disorders. Before *90210*, there was no such thing as women comparing their bodies to other standards and putting themselves down.

So big went from good to bad. One minute women were happily and contentedly living fully in their ample bodies, and the next they were awkwardly trying to starve themselves into someone else's standards. Sound familiar? I know that I was just fine as a sweetly chunky little girl, running around doing whatever little girls do. Being adored, mainly. I had not a care in the world. All was well. And then at some moment, my freedom was cruelly taken away from me by an incurable desire to be smaller.

This is insanely disastrous. A SWAT team should be rescuing women daily from the grips of such an irrational and deadly desire to be smaller than their healthy genetics allow. It is a tragic waste of our precious time and energy to want to be small.

And the physical smallness is only an outward symbol of the smallness that is truly being bred. Physical smallness, and the endless amounts of wasted energy spent trying to attain it, make us smaller minded and smaller spirited. Our life force is robbed of its longing to express itself. We rob our bodies, souls, spirits, and emotions of their right to take up space.

Size is good. I'm all for it. Big, sumptuous legs, thighs, and hips carry me up many mountain trails, coast me down ocean-front biking trails, and dance me into ecstasy regularly. My generous belly holds all of me, especially my center of sexuality and creativity. Broad shoulders and big arms have massaged many a client and men who held my heart. My generous rib cage carries lungs that breathe me through many of life's triumphs and challenges.

Is it really all that cool to look like a wasted heroin addict or dying AIDS victim? No! That's the answer. Plain and simple. No, it is not attractive to whither away. It also doesn't feel very good.

I am all for feeling good, healthy, vital, and energetic. Energy needs space to be stored in our bodies. If there is no bulk, there are no energy reserves. No energy, no vigor, no power, no get-up-and-go.

REFLECTIONS

I say, let's all be big. Let's be big in many ways. Let's have big hearts and big spirits. Big minds, muscles, and energy. Let's take up space in the world and spread our spirits. Let's live large. Walk tall. Let's be considerable. Full size. Life size.

CURVO QUOTES
(IN YOUR WORDS)

"I've been called big. In Los Angeles (or most anywhere in Western culture), it means to me 'flawed.' It freaks me out." – Molly, actress

"I REMEMBER BEING DESCRIBED AS A 'BIG GIRL' AS A TEENAGER, AND TO ME, THIS MEANT FAT. ONE TIME, I WAS REJECTED BY A DANCE TEACHER WHO TOLD ME I WAS 'TOO HEAVY' TO TAKE BALLET. PERHAPS HE WAS TERRIFIED OF LOUD, ACTUAL-SIZED WOMEN."
– SARK, author[68]

CURVO INFO
(JUST THE FACTS)

"For centuries, large, lower bodies were the mark of sexiness for South Africa's indigenous women. In fact, women of the Ndebele—one of the largest native populations—wore large, beaded waist and leg hoops called golwani, stuffed with rubber to produce a larger-than-life bottom half. These padded costumes symbolized rolls of body fat, considered marks of beauty. The Zulu, another South African tribe, created rituals to highlight women's hips and legs. 'Among black natives, large buttocks and thighs were considered signs of womanliness,' says anthropologist Dr. Carolyn Martin Shaw, of the University of California Santa Cruz." – *Marie Claire*[69]

@ @ @

"When Harvard Medical School anthropologist and psychiatrist Dr. Anne Becker was studying the women of Fiji in the 1980s, she found that two-thirds of the population were overweight or obese, compared to our standards.

Amazingly, almost one in five obese women surveyed said they wished to gain even more weight. 'In Fiji, social position was partly determined by how well you were fed. At any meal, you were supposed to eat beyond the point of fullness. In particular, large calves were a mark of attractiveness. Thick calves were equated with a woman's ability to do work—a valued attribute,' explains Dr. Becker. 'Calling someone 'skinny legs' was the ultimate insult.'" – *Marie Claire*[70]

CELEBRITY CURVOLATION
(WHAT THE CELEBS SAY)

"IF YOU ARE A BIG GIRL LIKE ME, YOU CAN EITHER
DESTROY YOUR SPIRIT, WHICH I TRIED—BELIEVE ME,
I TRIED. I TRIED TO KILL MYSELF, BASICALLY,
AND WASN'T ABLE TO DO IT—OR YOU CAN
ACCEPT AND LOVE YOURSELF JUST THE WAY YOU
ARE. FACE IT, MORE WOMEN LOOK LIKE ME THAN
JULIA ROBERTS. WHY CAN'T THE FAT GIRL END UP
WITH THE PRINCE? I'M THE ONLY FAT, YOUNGER
ACTRESS RIGHT NOW. I GET MAIL, AND
IT BREAKS MY HEART—THE AMOUNT OF
SELF—LOATHING OUT THERE; THE AMOUNT
OF PAIN, SIMPLY BECAUSE PEOPLE ARE FAT."
– Camyrn Manheim, actress[71]

"I was always a big kid, and I'm okay with that, but I know that it would have been better growing up if I had seen role models who had figures like me. Beauty comes in all different packages." – Mia Tyler, plus-size model and sister of Liv Tyler[72]

"I was 102 pounds, and people at the record label were telling me that I needed to lose weight. The song is saying that I am worthy to feel beautiful in my skin. It's something that every woman experiences in one way or another." – Jessica Simpson, singer[73]

CURVO QUERY
(ASK YOURSELF)

- Do I falsely believe that big is bad and small is good?

- Do I think small women get more love, appreciation, and adulation?

- Do I put myself down for being big?

- Do I ever appreciate the strength, vitality, and health of my bigness or bigger parts, whatever they may be?

CURVO TURBO
(TRY THIS CURVOLUTIONARY ACT)

Make a CurvOlutionary Commitment to create an unofficial big women's society among your friends and encourage each other to be big in all kinds of ways. Big meaning that you are allowed to take up space physically, emotionally, psychically, and creatively. Egg each other on to embrace your bigness of thought, speech, heart, and body.

CURVOSIZE
(WHY EXERCISE WHEN YOU CAN CURVOSIZE?)

Create a big sensation, make a huge splash, generate gigantic waves—swim! What an incredible way to feel buoyant, supported by water, weightless, lifted, rocked, and swayed. Get in the water and move around. Nothing will make you feel more refreshed and help you to abandon any thought of size. Bodies of water can hold us, no problem, no matter what size.

AFFIRM THE CURVE
(POSITIVELY SWEET-TALK YOURSELF)

My presence and my healthy body can be as big as I want them to be.

DRESSING ROOM DRAMA

GET IN, GET OUT!

~

"I was having a problem finding sportswear with a hip edge to it. When you can't find clothes that reflect your personality, it's frustrating to feel you have to look like the second sister or a matronly mother." – Emme, plus-size model[74]

As I ventured out of my tiny dressing room to check the fit of my clothes, I sensed a woman-in-emergency occupying the center vortex of the leering, angled three-way-mirror. Her meltdown was happening right in front of my very eyes as she performed a pretzel-like yoga twist and gave a jeering, disgruntled, and disgusted stare at her rear end in the mirror. I could feel her temperature rising and practically see her internal landscape turn red. Instinctively assessing the situation, volleying through all possible options to distract her, I decided upon humorous self-degradation to get her mind off of her behind. "Man, is it just me, or are these clothes made for skinny midgets?" I said to her with a lighthearted laugh, tugging at the ill-fitting waist of my pants.

You see, dressing room drama is all too familiar to me and countless millions of women who so want to look like the models effortlessly slouching in those clothes up on the walls of our favorite boutiques. Unfortunately, something usually goes wrong, really wrong, in translation between what clothes look like hanging off those size-two storefront mannequins and the reality of the fitting room. The disparity between our hopeful anticipation as we stand at the rack of beautiful possibilities and the actuality of the ill-fitting mess they usually turn into on one's own body can drive any woman mad. Or at least sear a few holes in her fragile self-esteem.

Rachel's Rant:
Dressing rooms are brutal. They should all have government-regulated warning signs posted in full view: "Warning! Hazardous environment ahead! Women, children, and girls—don't try this at home, as it can cause major anguish, self-loathing, and drama!"

Trying on clothes can be a sentence worse than death for many women. I know I personally have to briefly converse with God before venturing into such dangerous territory. We have some words about my emotional, psychological, and physical state that day and decide whether I am safe enough to traverse such treacherous battlegrounds. If I am vulnerable that day in any way, feeling low, unstable, or just not totally on top of the world, we deem it an unsafe

day for clothes shopping and the dressing room. It's just like the ocean surf conditions posted on lifeguard stands: The big blackboard reports all variant natural factors like the tides, swells, temperatures, undertows, sunsets, and sunrises, and the surfer then determines whether or not it is an appropriate day to hit the waves. Likewise, the dressing room is not a place to be ventured into without careful consideration of all pertinent internal temperatures.

The reason for this trepidation is multifaceted. First you have the fact that the lighting is definitely made to induce tears from even the most self-confident shopper. Somehow the stark, bright florescent lights dutifully illuminate the very worst of all of us. I could have walked out of the house feeling like a million bucks, and then instantly, in the light of the fluorescents, I am reduced to a pimply, bulbous, bad-haired mess. This is a given; we all know this. But the angle of the lighting is wack, too. It's like its sole purpose is to shadow our cellulite and highlight every possible bulge like a prison watchtower intent on finding an escapee. Its artificial glare inevitably highlights our weakest link, usually in the form of some formerly unknown pocket of flesh or indention of cellulite.

And then there is that strange way the mirrors either insult our intelligence by stretching us out way longer than we actually are, or exaggerate all of our worst insecurities by squashing us into uneven tater tots. It is almost like the dressing room mirrors are calibrated for doom. As if they were all bought from the "tormentyourshoppers.com" online guide to circus mirrors. I've actually test-peeped in many dressing room mirrors to find that I looked completely different from one looking glass to the next.

You also gotta love the special recipe for disaster waiting for us at the trifold mirror. There we get the extra-special triptych version of our profile in one of two varieties. You get the straight-on, frontal version flanked by two side views that invariably reveal either a bulging pooch or a zit under your left jaw you never noticed before. Or, you turn around to get that rear-end view so rarely reflected by regular home mirrors, and then you're not believing this is what everyone sees when they are behind you. And of course something must be done to solve the flat hair on the back of your head. You just can't win when

you're dealing with three mirrors that then go on to exponentially create endless replications of our flaws. It's a formula for full-blown failure.

Then there is the issue of arbitrary sizing. Every store, brand, and designer has an entirely different calibration of sizing, leading you to all sorts of egomaniacal gymnastics during the trying-on process. We all seem to think that the smaller the number on the tag, the better. We then use our ingenious deduction to think that the smaller the number on the tag, the better we are. What BS. Especially because some designers actually admit to simply making up sizes based on their favorite-size model, combined with their favorite number. Hence that particular set of measurements, whatever it is, becomes a size six. Not much rhyme or reason to it, and it sure ain't personal, folks. Yet we have complete bipolar swings of our disposition when we either do or don't fit into that chosen number. Nothing changed on our body. All body parts are seemingly the same exact size they were with the last garment tried on, yet our spirits are either uplifted or shot down cold by that all-important number on the tiny tag.

Phew. It's a jungle in there. It takes a strong constitution and a self-esteem of steel to make it through a day of shopping without falling prey to all the pitfalls of vanity looming in every dressing room.

My strategy has been speed. I move in and out of the dressing room with a fervor not met by many clothing establishments. I've found that lingering is death in such situations. The dressing room must be handled with quick, swift action. Easy in and easy out of those clothes. No stopping to examine any piece or part of my body for too long. If the clothing doesn't fit, take it off and try on the next and the next until either one does fit or it's time to go. No thinking about it. This is not the time for process and analysis, ladies! This is the time to get in and get out while incurring as little harm as possible.

Unfortunately, I've noticed that not many other women subscribe to this stealthy dressing room agenda, but instead fall prey to the timeless trap of self-degradation offered by all the formerly mentioned fitting room pitfalls. I've often fancied myself the Faery of the Dressing Room: Glenda, the Good Witch of the Fitting Room or Ms. Queenie Good Fit. I would wave my magic, sparkling wand

and make it all better for every woman struggling to keep her eyes from tearing up at the ill fits and mean reflections. I'd be able to tastefully dress them with a fabulous fit and stunning style in one whimsical wave of my magic wand. They would instantly experience, on their very own perfect bodies, a better, more flattering fit. I could breathtakingly change their bad-fit episode into a perfect-fit day. All the dresses, skirts, jeans, and tight tees would look absolutely to-die-for on them, bolstering their self-esteem to new heights. They could see only how beautiful they were in those benign mirrors, getting into and out of clothing and the dressing room with not so much as a tiny scrape or bruise.

Or, on a more sober, less fanciful day, I've considered setting up a clothes-fitting self-help group, aiding dressing room casualties in picking up their self-esteem and moving on to greener pastures.

REFLECTIONS

Remember those relay races you used to do back in school where you had to run across a room to a pile of big clothes, hurriedly put them on, relay back, and transfer that outfit to your next baton carrier? The game went on and on until your whole team had dressed and undressed, charging back and forth. That was good exercise and good fun, and you paid no heed to the fashion or fit of clothing. Imagine if that could be our carefree experience of the fitting room. If it didn't fit you, you'd quickly pass it on over to your friend, because you simply couldn't wait to go and try on the next one.

CURVO QUOTES
(IN YOUR WORDS)

"My most painful dressing room memory
(which persists to this day): Growing up in Michigan,
it was necessary to have boots for the winter snows.
My calves were too large, and I could never get a
knee-high boot to zip up. As a fifty-year-old woman,
thinner than I was as an adolescent, I recently

put on a boot and tried to zip it up-to no avail.
The humiliation was still there . . . slightly less so,
but still fresh and painful some thirty-five
years later!" – Marty, saleswoman

"IT'S ALWAYS A REALITY CHECK TO GO INTO A CLOTHING
STORE AND LOOK INTO THAT FULL-LENGTH MIRROR.
BECAUSE IT SEEMS THAT NO MATTER WHAT YOUR BODY
TYPE IS, THE CLOTHING DESIGNERS ARE DESIGNING FOR
SOMEONE ELSE'S BODY. . . . IT'S A NO-BRAINER IN THE
FASHION INDUSTRY. TO SELL CLOTHES, YOU USE THE
MODELS WHO'VE GOT 'THE LOOK.' YOU KNOW IT, LONG AND
LEAN—A FAT-FREE MACHINE! THIS IS THE FIGURE THAT
SO MANY AMERICAN WOMEN ASPIRE TO HAVE. I MEAN, WHO
WOULDN'T WANT TO LOOK LIKE THIS IN A LITTLE BLACK
DRESS? BUT THE REALITY IS, THIS BODY SIZE IS UNATTAIN-
ABLE FOR MOST AMERICAN WOMEN." – Dr. Judith S. Stern, author[75]

CURVO INFO
(JUST THE FACTS)

"American girls typically evaluate the success or failure of their personal
body project in dressing rooms at the local mall or department store. . . . In the
retail business, the common wisdom is that girls try on approximately fourteen
pairs of jeans for every one that they eventually purchase. . . . Because every
female clothing company develops its own sizes and proportions, there is no
standardized equivalent between body measurements and size. Hips that are
thirty-six inches, for example, do not always equal size twelve. . . . In front of a
three-way mirror, usually under harsh, uncompromising lights, the adolescent
girl assesses herself in terms of the current quest for bodily perfection."
– Joan Jacobs Brumberg, author[76]

Gender differences extend to how we see ourselves, according to research reported on abcnews.com. In the study, male and female students were asked to try on a sweater or swimwear. The dressing room included a full-length mirror. Researchers told the students to keep the garment on for fifteen minutes to determine whether they liked it. During the trying-on period, they were asked to also take a math test.

The math test results were generally the same for the men no matter what they were wearing, but those wearing swim trunks did slightly better. However, the women did worse on the test if they were wearing a swimsuit. Even though each woman was in the dressing room by herself, she was apparently distracted by what she saw in the mirror.

CELEBRITY CURVOLATION
(WHAT THE CELEBS SAY)

"I DISAPPOINT PEOPLE WHO MEET ME IN PERSON BECAUSE I DON'T LOOK LIKE ME. BUT THE PUBLIC IS REALLY HARD ON PEOPLE IN THE INDUSTRY, AND YOUR IMAGE HAS TO BE PERFECT, AND I OPENLY ADMIT THAT I HAVE CELLULITE AND I GET THAT TOUCHED OFF."

– Tyra Banks, model and producer, speaking about airbrushing in magazines[77]

"I feel pressure to fit in my clothes."

– Hilary Duff, actress and singer[78]

CURVO QUERY
(ASK YOURSELF)

◎ Do I judge myself negatively in the dressing room?

◎ Do I spend too long harshly cutting myself down in the dressing room?

◎ Do I put myself down if I don't fit into a smaller size?

 Do I falsely believe that a smaller size would mean I am better or more attractive?

CURVO TURBO
(TRY THIS CURVOLUTIONARY ACT)

Make a CurvOlutionary Commitment to create a quick 'n easy, in-and-out dressing room plan. Use the dressing room solely as a place to find out if the clothes fit. The minute they do or don't, you are out of there. No questions asked, no neuroses milked, no processing and analyzing allowed. I limit my dressing room time to the shortest possible time to get my clothes off, the new ones on, a quick glance or two, a yes or a no, a change back to my old clothes . . . and out I go. You are only in there to try on the clothing, not to scrutinize every last inch of your body over and over again.

CURVOSIZE
(WHY EXERCISE WHEN YOU CAN CURVOSIZE?)

A simple way to feel better in the dressing room is to feel better about your body. A way to feel better about your body is to moderately exercise it. A way to moderately exercise it is to walk it adequately on a daily basis. Heck, why not combine the two pursuits and walk or ride your bicycle to the next place you try on clothing. That way you arrive already feeling invigorated and body positive. I always shop close to home so that I can walk or ride my bike, and then I have a healthy, fast, and fun escape hatch if I feel battered by the dressing room.

AFFIRM THE CURVE
(POSITIVELY SWEET-TALK YOURSELF)

Dressing rooms are friendly places where I find clothes that either fit or don't fit.

WHEN DID BELLY BECOME A BAD WORD?

WHO CARES? FREE YOUR BELLY!

"I don't have great thighs, I have very big breasts and a soft, fatty little tummy." – Jamie Lee Curtis, actress[79]

I found myself staring, unflinchingly, at my belly in the mirror. I'd look one way, then another. I'd turn to the side and pull my abdomen in as tight as I possibly could, then let it out again. Over and over again. I'd grab my flesh, cursing the "excess" in my hands. Then one day I had an awakening of sorts. I actually thought about the fact that I have real, live organs underneath this surface. My belly doesn't really even house my stomach. That's up way higher in my torso. No, actually what lay just beneath the surface of this sorely scrutinized area were my uterus and my fallopian tubes, the intricate, delicate procreational organs that only a woman has. What if the slight bulge in my belly indicated larger, healthier, juicier, life-giving feminine organs? Perhaps my pooch illustrated the gift Mother Nature had bestowed upon me. Huh, I had never thought of it that way.

Rachel's Rant:
Bellies are badass and belly buttons rock. Remember the Pillsbury Dough Boy? And come on . . . what about the big ol' laughing Buddha belly on every yoga T-shirt these days? That potbelly is making a big comeback! Bellies are back, and they are good, holy, and well deserving of our attention and acceptance.

My belly has always been an attention getter. There is something comforting and soothing to others about the sloping convexity of my pooch, a childish innocence in the way it playfully sticks out past the boundaries of my hipbones. And because of this, men and women alike have found it completely acceptable to randomly reach out and touch my abdomen, the same way pregnant women are accosted by unsolicited petting and oohing and aahing at their protruding roundness.

I didn't ask for my sticky-outy belly. Nope, not at all. I, like every other naturally born and bred American woman, have kicked and screamed, hooped and hollered for a flat stomach. In fact, I wanted more than just a flat belly; I wanted one just like the models had: concave and hollow. And, for a brief moment in time, I had it. I can remember all those days at the neighborhood swimming pool in my high school years, lying in the grass atop my multi-colored

towel, proudly glancing down at my sunken belly button, hanging inches below my hipbones. I was elated. I could have died and gone to heaven right then and there at the ripe age of sixteen, having fulfilled my life's mission of achieving the perfectly skinny stomach.

Of course, you know the rest of the story. It didn't last. How could it? First of all, I was practically a baby—just a girl. Second of all, my genetics, bone structure, and budding feminine curves had other plans in store for me entirely. As womanhood beckoned and my body began to fill out, a slight roundness shaped my midsection. I was mortified. What was happening to the perfect concavity I had achieved for that fleeting moment in my teenage years?

I set out on a mission to flatten my tummy, no matter what it took. (See Chapter 5: "Help, I'm on the StairMaster and I can't get off!") I also developed a pesky habit of angrily staring at it in the mirror, nonstop. At every angle conceivable, I would examine just exactly what my belly was doing and its varying appearances from every viewpoint possible. I wanted to make sure that I knew exactly what others were seeing. Unfortunately, this behavior developed into an obsession of beating myself up for not having the abs I so admired on all the women's midsections exposed in print. The ink of the day was tearing me up. The pictures had me mesmerized, hypnotized, and determined to achieve that elusive, yet gloriously flat stomach.

But, as I mentioned, my genetics had something else in mind. The stubborn sway of my stomach just wasn't going away, no matter how many gazillion crunches, laps, or hours I logged. Eventually, I surrendered to the size and shape of my belly. I had no choice. It wasn't budging, and my body functioned just perfectly as it was. Like it or not, my pooch was here to stay. So, I decided to like it.

What has caught my attention all these years is how inviting my belly is to others. Judging by the number of times people have literally reached for my bare belly, there seems to be a magnetic quality my tummy holds over others—a novelty and a boldness that attracts attention when I least expect it. Like I said, I surrendered to the size of my belly and decided it most advantageous to go on like the others who have what I want and wear midriff-revealing tanks and tops

when I feel like it, ignoring the fact that I am "supposed" to have a flat tummy to do so. And invariably, when my belly button and the surrounding area are exposed, someone will come right on up and place their hands on my belly and say something sweet like, "Oh, it's so cute."

As if I, a thirty-something-year-old woman, want my belly to be perceived as cute. All right, all right, I admit, it is positive attention and has felt warm and sweet. I've thought a lot about these belly adorations coming my way. I've arrived at the simple fact that people like real bellies that bulge. There is a natural human urge to feel safe and comforted by the belly. Somewhere, somehow a perversion occurred in the fashion industry, departing drastically from the natural human love affair with the generous tummy.

The most remarkable evidence from the field supporting my theory comes from the overwhelmingly positive man-appeal my tummy solicits.

My pooch fascinates men. As soon as I've granted them permission to let their hands roam my torso's landscape, their paws always land right near my belly button. I've even had men park their hands on my belly the entire time we watched a video or snuggled and talked. It's uncanny, this sincere hunger for the belly.

Men crave belly. They love a good, healthy, soft, feminine tummy.

I've begun using my belly. It has powers, and I'm not above capitalizing on them. I now let just a little bit of my soft belly peek out from between my top and bottom garments. Just a taunt. A little tease. But it works! This blows my mind. Here the media are trying to tell us to starve the life out of our bellies in order to be desirable, while mine, gloriously strong with a good healthy layer of fat over the top, practically stops men in their tracks.

Ironic, huh?

Where did we go so wrong? Who said women are supposed to be flat-bellied? What percentage of women on the planet would actually have naturally occurring flat bellies, if they weren't starving or manically working them off everyday?

Our bellies want out!

A QUICK INTERLUDE ON BIKINIS

*"I had to do a bikini scene for
Legally Blonde, and I had to work-out like
a madwoman for three hours a day. I would
never do it again."* – Reese Witherspoon, actress[80]

Rachel's Rant:
Thank God for bikinis.
Remember all those
holiday meals and how
glad you were to just
unzip your pants and let
it all hang out? With bikinis,
the stripping's already
been done for you!

How many times have you heard this particular gem coming out of the mouth of a beer-bellied, balding man: "She's too fat to be wearing that bikini." Or worse, how many times have you heard, "She really shouldn't be wearing that bikini/that revealing of a top/that sexy of an outfit" from a woman?!

These comments allude to the false notion that only certain people are allowed to wear clothing that feels and looks good. These comments insinuate that only certain body types deserve to be shown publicly. These comments suck!

Living for the past five years in Venice Beach, California, as a size-twelve, 150-pound woman has been an excellent exercise in practicing what I've preached to my fellow females all these years: Love your body unconditionally. But when it came to exposing my own strong, thick frame for the first time among the impossibly long and lean-bellied, bronzed babes out on the boardwalk, I found a surprising amount of resistance threatening to keep me from playing. I realized this was my challenge, and I was up for it.

Getting a proper-fitting bikini was my first step. Seemingly simple, this can be a surprisingly complex task. Here is the understatement of the year: Not all bikinis are created equal. Bikinis and how they fit vary as wildly as the flora and fauna of the exotic Brazilian rainforest. As I tried on one suit after another,

I found my body looked entirely different from cut to cut. Some made me look like an awkward, chunky toddler, while others graced me with a flattering, feminine loveliness that even shocked the shopkeepers. It was remarkable how many assorted "Rachel looks" I could have with each suit. Some cut into me at all the wrong places, pushing my flesh into strange bulges, while others elegantly caressed my curves and held them like a mother holds her child, carefully and with love. I walked out with one of those, and promptly tested out my newfound fit on the beach.

What I found was startling. The world championed me and my self-assured body strutting along the boardwalk. Men were glad. And women were glad. I could tell that it was actually a relief for women to see another real-sized woman out there, boldly baring her body to the breeze.

And this is what my fellow CurvOlution warrioresses and I do. We support each other in donning the bikini and going public. It is a most liberating and confidence-bolstering activity. One of my friends, a particularly muscular, shapely woman, has had a complete metamorphosis from this process. We had gone on vacation together with a group of friends, visiting the ocean in the nude, and she would be the only one staunchly wrapping herself in large garments and towels, covering what she thought was an unacceptable body. She told me that when we returned home, her goal was to have the guts to go Rollerblading in her bikini. I thought there was no hope for her, as we would all try in vain to coax her out of her oversized clothes, unflatteringly covering her strong body.

Miracles do happen. And I am glad to say I've gotten to witness one with her. She came back from vacation, and we promptly donned our bikinis and rode our bikes along the ocean. This started our "bikini brigade" regime that's kept us tan, fit, and happily receiving admiring encouragement from men and other women alike. We've both been bowled over by how many men are so appreciative of our curvy forms cutting through the Pacific winds. As well, we've found that women have a peculiarly confused response to our bikini rides. There is almost a disconnect, an unknowing, an unfamiliarity in seeing healthy,

real-sized women proudly wearing more revealing suits. Used to seeing only the super-thin in bikinis, and challenged by their own unwillingness to cut loose, they see us and don't know what to think. Often we've witnessed an almost visible sigh of relief and positive vote of support as they open themselves to the possibility of expanding their idea of what is attractive to include themselves. They see that we are beautiful women, that we are not skinny, that we are in our bikinis joyously and unselfconsciously enjoying ourselves, and that perhaps they can do it too.

If skinny women are the only ones to reveal their bodies, then we exist in the false paradigm that they are the norm and that something is wrong with us if we have flesh on our bodies. If the only bellies we see outside are those tiny ones owned by less than forty percent of the population, a false notion is born that they are the only palatable ones. We start thinking only skinny bodies are legal. Pshaw!

Why are we covering ourselves up when we are the majority? Some of us must be brave and reveal our curves for the rest to know that we are the norm, and we are allowed to adore and adorn our curves!

REFLECTIONS

It is our duty as real, curvy women to bare our bodies to the wind, showing the world that we are proud and we are here. Sixty percent of American women are a size twelve or larger. We are the majority. Where are our bellies in the summertime? Hidden? Why? Let them out. The world needs and wants to see all women of all healthy sizes proudly walking the planet. It is entirely revolutionary to be proud of our bodies. And, it is sorely needed by the rest of us who sulk at the sight of yet another media-perfect body.

To deny the belly of size is to deny life. Without the belly, we die. Period. Why cramp your abdomen's style? Why squeeze it, pull it in, belittle it, or crowd it?

Bring your belly out for the day! No matter what size, shape, form or consistency. Bellies need air. They like to breathe in the sun. They like to see the daylight, feel the breeze, and be admired by others. You never know what hidden

opportunity is lying just around the corner in which your liberated belly can shine and thrive. Free it now!

CURVO QUOTES
(IN YOUR WORDS)

"*I REGARD MY BELLY AS SUCH A BEAUTIFUL PART OF MY BODY. IT GIVES ME MESSAGES, TELLS ME WHEN I AM HUNGRY, AFRAID, COMFORTABLE, SAFE.*" – Nadine, publicist

"I always loved to swim. When I started dieting as a teenager, I swore I'd never wear a bathing suit until I was the perfect size. It wasn't until a vacation at age thirty-three that I said, "Screw that!" and bought a comfortable suit for the beach." – Martha, editor

"I have a hard time accepting my belly, but my daughters love it. They can't wait to grow up and have a big one just like mine." – Terrie, entertainment executive

CURVO INFO
(JUST THE FACTS)

"For centuries in China, the most desirable women were slim by Western standards with 'a modest touch of fullness' in their midsection (the Chinese actually had a term for it: *feng man*). This body ideal was related to traditional Chinese-medicine principles that said a woman's qi, or vital energy, has its central reservoir in the abdomen. 'For the Chinese, a rounded belly translated into a woman of sexual desire, fertility, and strength,' says anthropologist Dr. Susan Brownell, an expert on Chinese culture at the University of Missouri-St. Louis." – *Marie Claire*[81]

CELEBRITY CURVOLATION
(WHAT THE CELEBS SAY)

"I've had a little lipo. I've had a little Botox. And you know what? None of it works. None of it."

– Jamie Lee Curtis, actress[82]

"How many hours a day do I think about my not-so-flat, post-forties stomach, dressing it, covering it, fantasizing about how it's supposed to look? If people come to the theater and actually experience loving their body for just ten minutes, I'll be very happy. I think women are deeply, deeply programmed to be good, and being good now means being thin, perfect, and flat-abbed." – Eve Ensler, playwright[83]

CURVO QUERY
(ASK YOURSELF)

- Do I negate my belly by sucking it in all of the time?

- Do I falsely think eating will make me have a big belly?

- Do I cruelly grab my belly and berate myself for having flesh?

- Have I ever considered what a blessing my belly is?

- Do I think I need to be a certain size to be allowed to wear a bikini?

- Have I ever wanted to wear a bikini, but didn't because I judged my body unworthy?

- Do I negatively judge other women as not have having a "perfect enough" body to wear a bikini?

CURVO TURBO
(TRY THIS CURVOLUTIONARY ACT)

Make a CurvOlutionary Commitment to let people you love and trust touch your belly. Just let it happen. Remember that babies, pets, and animals all love to have their bellies rubbed. You will, too, when you just allow it to happen. And why not make a double-duo CurvOlutionary Commitment to wear a bikini, despite yourself? It feels really good when the breeze blows the little peach fuzz on your abdomen.

CURVOSIZE
(WHY EXERCISE WHEN YOU CAN CURVOSIZE?)

Though there is no such thing as spot toning, here is a great way to strengthen your midsection. Notice I say strengthen, not carve, chisel, or sculpt. Want to know why? Because strength is what matters, and strength does not necessarily look like the airbrushed abs on a starving model. So a great way to support your abdominal area is to do very slow leg raises. The best way to do this is to lie flat on your back on the ground with your hands either right beside you or carefully placed just beneath your hips. Then, with the legs starting at a ninety-degree angle straight up, proceed to slowly lower them to a forty-five-degree angle, hold for a moment, and then back up again. Repeat a few times to feel your muscles toning. Remember to initiate the movement from a still point and from your midsection, not by swinging your legs. That's cheating.

AFFIRM THE CURVE
(POSITIVELY SWEET-TALK YOURSELF)

My belly is ultimately feminine and inviting.

BRING ON THE BIGGER BODIES
CONFESSIONS OF A MASSAGE THERAPIST

"Getting my lifelong weight struggle under control has come from a process of treating myself as well as I treat others in every way." – Oprah Winfrey, media mogul[84]

The story was always the same. One of my massage therapy clients would have thoughtfully and generously sprung for a gift certificate to give her best friend a massage for the holidays. We would wait and wait for the recipient to call in and redeem her present. But, alas, she never would. My client would make the call to find out why she had not scheduled, and invariably the receiver would hem and haw around the topic and finally just admit that she felt too embarrassed about her overweight body to cash in her certificate. Depriving oneself of touch due to body loathing—how truly sad.

In our size-obsessed society, I feel the need to make this announcement loud and clear: Bigger bodies are more fun. As a massage therapist for the past ten years, I've noticed one thing for sure: bodies with substance, curves, and shape just plain feel better. There is something so indescribably pleasing about a nice, voluptuous, plush body.

Rachel's Rant:
Our bodies are meant to give us a whole lot of pleasure, and hating them does not aid in this endeavor.

Their tissues feel happier, more vibrant and alive. Their bodies have more play, feel, movement, and rebound.

Unfortunately, many people are self-conscious of their body flaws when getting on the table. They are concerned about the superficial look of their body in such an intimate setting. Apologetic women don't want their fat or cellulite revealed. I've felt the deep shame and body loathing as women agonizingly reveal their insecurities with negative remarks about their size.

Please hear this: Having worked as both a fitness professional and massage therapist at a hip, slick, and cool gym in West Hollywood, replete with ESPN fitness pros, models, and actresses padding around the locker room in their birthday suits, I can say with certainty that they have cellulite. Every last one of them.

All women have cellulite, no matter how skinny, fit, or toned. Period. As one who has my hands and elbows on bodies every day—constantly kneading,

working, pulling, stretching, and releasing tension—I must say for myself, and for many of us, bring on your body, your whole body, and nothing but your body. Leave your old, nagging insecurities and your mean ol' ego's damaging vanities and self-judgment outside the massage room.

Massage is for all bodies, regardless of composition percentages and measurements.

In the safe, boundaried, and nurturing environment of the massage room, there is no such thing as a body part that is too big, too small, or wrong in any way. We are not scrutinizing your body parts at all. In fact, most therapists I know, including myself, work with our eyes closed, going for the internal energy reading of the body. We feel for how the body moves or stagnates, lies on the table, holds tension, and responds to pressure. We are not looking or comparing in any way.

The very first documented massage therapists were actually the blind healers in China. They were the most coveted, revered, and respected therapists, for they worked entirely in the realm of the unseen, using their highly developed senses of touch to benefit their patients.

In truth, you can practically put massage therapists into the category of doctor, surgeon, dentist, or gynecologist. We experience your body as a challenge to practice our skills and wisdom on, not a piece of meat for objectification. Actually, most massage therapists I know are like geeky mad scientists, completely engaged in the almost academic pursuit of problem solving.

The function and health of our bodies have very little to do with the size we are in comparison to others. Our bodies work best when we are healthy in relation to our own genetic encoding, not in comparison to some impossible standard based on the elite and abnormal. Bodies are happiest inside and out when they are moderately fit and completely loved by their owners.

A healthy body, a body that feels good to its owner and to a massage therapist, is one that is nurtured, tended to in moderate and balanced ways, loved through proper food and exercise, talked to in loving ways, and always treated with kindness.

I can always tell a body that is being abused, neglected, poisoned, overworked, or berated. It feels tight, taut, hardened, unforgiving, immobile, and stuck. In fact, oddly enough, I will actually start feeling anger and restriction inside my own body when working on these people.

I can energetically feel eating disorders and body image obsessions in my clients. There is a certain ill-at-easeness and rigidity in the very feel of their tissue. Their breath is shallow. Their bodies do not give and actually induce discomfort in me. They do not fully receive what is being given them.

Likewise, when an unhealthily overweight woman lies on my table, I can feel her self-disapproval through the way her body speaks. She may not give me her limbs and her shoulders stay closed in tight up next to her ears as her shallow breath denies any release. She stays in a state of defensive self-protection. She does not let go and allow me to help her. The body-disconnect in these clients prevents them from fully absorbing the benefits of touch.

More prevalent are the types that avoid massage therapy altogether due to their insecurities. I cannot tell you the number of people I've told I was a massage therapist only to witness them shyly admit that they've shirked away from receiving massage due to self-consciousness. It is heartbreaking that the ones who need the love the most are unable to accept the very medicine that might soothe their ailment of low self-esteem.

Massage therapy can be an effective tool, instigating the breakthrough from body shame to acceptance. I suffered many years with eating and exercise disorders that had me on a never-ending treadmill of body dissatisfaction. I had an ever-shifting and precarious idea of my weight. I would not allow myself to eat if I hadn't exercised enough, and then once I ate, I had to exercise again. I actually thought my body size fluctuated between these two tightly woven activities and would deem myself undeserving of any pleasures if I thought I was on the high end of the scale at any given moment.

Massage therapy began my healing process. I went in due to debilitating neck and back pain, undoubtedly from overexercising and the constant self-obsessed state of my emotions. I will never forget the novelty of my first sessions on

the table. At first, I'd hold my arms, legs, and neck tight to my body and chat incessantly, feeling the need to protect myself in every way possible. I did not want to be vulnerable, let my guard down, or reveal any of my highly scrutinized body parts.

My therapist broke through all my layers. She was organic and healthy, thick and strong. She coaxed me out of my self-consciousness and into surrender. I found myself gradually giving in to her guidance through each successive appointment. I'd follow her breath, be silent, go in and out of near-sleep, and, most importantly, let my body be loved unconditionally for the first time ever.

I learned that I was entitled to receive. I learned that it was her pleasure to give to me. I learned what a blessing it is to gracefully receive someone else's gift. I learned that my body was parched for this kind of profoundly nurturing touch.

A few years later, based on this positive experience, I became a massage therapist and now revel in the pleasure of contributing to my clients' commitments to self-care. Nothing is more pleasurable and satisfying to me as a massage therapist than when I sense a profound body comfort in my client. These clients come in all shapes and sizes. People who are in touch with and at peace with their bodies breathe, relax, surrender, and release. Our sessions feel organic. Their tissues melt and respond, their breath is deep, and they allow themselves to receive. Healthy bodies come in as many shapes and sizes as there are people on the planet. Let yours be what it wants to be. Respect your body enough to honor its rhythms and natural weight fluctuations.

REFLECTIONS

And most importantly, love your body enough to nurture it with the most valuable healing element known to man—touch.

CURVO QUOTES
(IN YOUR WORDS)

"I'VE NEVER LET MYSELF GET A MASSAGE BECAUSE I THINK I'M TOO FAT. I'M TOO SELF-CONSCIOUS OF THE MASSAGE THERAPIST JUDGING MY BODY. I JUST COULDN'T RELAX." – Tonya, seamstress

"I won't go to hot springs or spas. I feel too fat to parade around in front of other people."
– Alice, writer

CURVO INFO
(JUST THE FACTS)

As a massage therapist for over ten years, I've found that massage therapy aids in body image problems. Massage is very healing work that can address the emotional holding behind the physical tension. It is a way for women to begin accepting their bodies. I've found it to be particularly helpful when working with body image, grief, trauma, frustrating control patterns, developmental issues, and addictions.

CELEBRITY CURVOLATION
(WHAT THE CELEBS SAY)

"MY FIRST SPLURGE [AFTER HER FIRST PAYCHECK] WAS A MASSAGE. I HADN'T EVER HAD A PROFESSIONAL MASSAGE BEFORE AT A SPA, AND SOMEONE HAD SAID TO ME, 'YOU'RE WORKING SO HARD, AND WHAT YOU DO IS SO PHYSICAL, YOU KNOW? YOU WOULD REALLY BENEFIT FROM HAVING A MASSAGE'. . . . AND I HAD ONE, AND LO AND BEHOLD, IT REALLY MADE A DIFFERENCE." – Debra Messing, actress[85]

CURVO QUERY
(ASK YOURSELF)

- ◉ Do I deny myself pleasurable self-care because I think I am too big?

- ◉ Do I think others are more deserving of self-care than I due to body size?

- ◉ Do I think being big is a reason not to get massage, go to spas, gyms, pools, etc.?

- ◉ Do I ever let myself receive massage and safe, loving touch just to nurture myself and because I deserve it, simply because I am alive and a good person?

CURVO TURBO
(TRY THIS CURVOLUTIONARY ACT)

Make a CurvOlutionary Commitment to treat yourself to all sorts of nurturing body treatments. You deserve it. Walk around naked at a spa. Notice that everyone else has really normal bodies with all sorts of creases and bulges. Their curves are absolutely typical. And so are yours. I cannot tell you how healing it has been for me to get bodywork done and to allow myself to be nude at spas with all the other women of different sizes, shapes, and colors, and to realize we are all just variations of flesh and blood. And that we all have cellulite!

CURVOSIZE
(WHY EXERCISE WHEN YOU CAN CURVOSIZE?)

Stretching is something massage therapists do for their clients. It feels really good and, better yet, is good for you, preventing injuries. You can do it all on your own. Put on some soothing music and spend ten to fifteen minutes just breathing, stretching, and loving on your body. Remember that stretches are most effective when slowly eased into and held for at least thirty seconds. Don't hold your breath. Make sure to gently deepen your breath, lengthening both the inhales and the exhales, as they both help to melt away tension.

AFFIRM THE CURVE
(POSITIVELY SWEET-TALK YOURSELF)

My body deserves the most loving treatment I can give it. I now take immaculate care of my body.

CURVOLUTION SOLUTION

I hope you've enjoyed the ride of this book so far. I'd now like to introduce you to CurvOlution. I always knew I was supposed to do something important and powerful about women, body image and the media. Twelve years ago, back in Ohio, I wanted to start a stark-raving-mad women's group that picketed clothing stores for their one-faceted portrayal of women. Thank goodness nobody joined my group, because angry, festering women are neither a pretty sight nor a very powerful force. Anger is only met with more anger. It cannot inherently birth anything new, salient, and barrier breaking.

Fortunately I made it through my furious, rebellious, anti-establishment days to a new place of positivity and hope. Therefore, instead of starting an irate gaggle of enraged, irrational women, my business partner, Tonya Sandis, and I founded CurvOlution, a Size Acceptance Movement that joyously entertains, informs and educates girls and women to stop obsessively struggling to change their bodies and to start loving and accepting the ones they have.

Our CurvO CredO is our statement of principles and beliefs, and it goes a little something like this:

1. Beauty is not a size and fitness is not a shape.
2. At our optimal health and fitness, we are different sizes.
3. Obsession increases the problem, whereas acceptance eradicates it.

Here's the hi-fi lowdown on each CurvOlutionary crux:

1. BEAUTY IS NOT A SIZE, AND FITNESS IS NOT A SHAPE.

"There's more to life than cheekbones."

– Kate Winslet, actress[86]

Many cultures throughout the world and throughout history have revered women as beautiful at a myriad of different sizes. You read about the women of Nigeria, Fiji, China, and South Africa who've all been prized for their size. There is no one size that is beautiful. In fact, size has nothing to do with beauty.

I also learned in my career as a fitness professional at some of the hippest gyms in L.A. that fitness is not a shape. I would walk into my gym, look up at the TV monitors and see my fellow instructors starring in ESPN's morning programs, but later witness them eating In n' Out burgers, slamming ephedrine drinks, and sporting the most negative attitudes ever. I could run circles around them, ate clean as a whistle, and wondered why they were considered more "fit" than me. The fact is that they weren't . In truth, some of them were the least fit people I've known; they were just genetically endowed with that look the media love to love.

Moreover, the shapes we see on the cover of all the fitness magazines are not what fitness is about at all. Fitness is an internal state of the body. In her classic book *Body Wars*, Margo Maines states outright that average to slightly thicker bodies are actually the better recipe for health and fitness. Read it—it's amazing.

2. AT OUR OPTIMAL HEALTH AND FITNESS, WE ARE DIFFERENT SIZES.

"My responsibility is to keep myself in a certain level of shape and health. But my body type is my body type, and I am not going to starve myself."

– Drew Barrymore, actress[87]

Okay, here's the deal, folks: Line up ten of us, give us all the same exact food and make us do the same exact exercise for as long as you like, and guess what? We will all still be ten different sizes. We have diverse body types. Check out the new baby ward at any hospital and you will find babies with different body configurations. They haven't even had a chance yet to enhance or screw themselves up with diet and exercise.

Genetics—what a concept.

Our bodies have their own unique set points, a weight and size we will settle at when in optimal health conditions. Our individual set point is genetically encoded and does not care what our neighbor, friend, or woman on the billboard looks like.

I once had a friend, a former international model, who had one of those gravity-defying body types: five foot ten, 110 pounds, and turned every male head for miles. She and I went on a 2½-day mountain-hiking trip, spending pretty much every waking, eating and exercising moment together. Thinking she must starve herself to maintain her long, lanky, wiry, muscular physique, I was startled to notice that she ate just as much, if not more, than I did. Plus, I smoked her on every mountain, leaving her in the dust. As we were driving back

148

from our adventure, I humbly admitted to her that I thought certainly she must eat a lot less and exercise a lot more than I to have that skinny body. She in turn confessed that she thought for sure I must eat a lot more and exercise a lot less than she to have my size 12, 150-pound build. We both sat astonished, realizing how false our ideas about body types and their changeability had been.

No amount of overexercise or food deprivation will ever take us very far from our set point. Not for long, anyway. Our bodies will resume a natural size when in optimal conditions: when fed right, exercised moderately, rested well and loved unconditionally.

Our definition of optimal health and fitness?

1. You wake up with energy and have it all day long. Simple. An optimally healthy person has get-up-and-go vitality that carries her through a moderate day full of activity, career or academic pursuits, and creative endeavors.

2. You can touch your toes and walk 30 minutes and feel better for it. Fitness means suitability of somebody to a particular purpose. It does not mean you look like a ripped Olympian on speed, leaping tall buildings faster than Superwoman and climbing large cityscapes like Spiderwoman. Fitness means you can perform moderate tasks that your body was made for.

3. You feel more positive than negative on a daily basis. Optimal health and fitness is not just that of the body; it also includes the mind. A healthy mind is a positive, thriving, growing mind. Yes, it struggles, but it is always striving for the gold at the end of the rainbow, glorying in its triumphs and relaxing in its quiet moments.

3. OBSESSION INCREASES THE PROBLEM, WHEREAS ACCEPTANCE ERADICATES IT.

"Can you imagine the energy that would be unleashed if women stopped obsessing about their bodies? The money, time and attention we could put somewhere else? It would be a new wave of female empowerment. We could really transform the world."

– Eve Ensler, playwright[88]

Whatever we focus on grows. Constant concentration on our physical deficits, shortcomings, and eating behaviors begets more of the same. Stop doing it and the problem shrivels up and dies off. I know because that's what happened with me.

Extreme deprivation, containment, and restriction create unruly and consuming obsession. This has been recorded in starved prison camp survivors who then go on to irrationally hoard food. I've experienced first-hand the insanity bred in bodybuilders who put themselves through inhuman dietary restrictions to "lean down" prior to competitions. They looked just like you and me during their off season. Their musculature lay underneath the healthy layer of fat and skin that naturally protects and nourishes our bodies. But then they started the slow, mean competition countdown and literally starved themselves of fluids and nutrients so that all normal flesh disappeared to reveal their unprotected musculature and veins. During this time they became the most irritable, moody, crazed humans on the planet. They also developed one peculiar transfixion that never ceased to amaze and amuse me. As their

bodies leaned down to outré-human proportions, they simultaneously became fanatically gripped with food preoccupation. They would scheme, write lists, and fantasize for hours about the exact flavor of Ben & Jerry's, the toppings on their Pizza Hut pizza, and the number of Snickers bars they would consume whole the minute, second, and nanosecond their competition was over. This mania overrode any concern as to whether they even won their heat. All they wanted to do was eat.

I rest my case. Obsession creates obsession.

The only way to end it is to stop it. When we cease to feed our neurotic worries and behaviors, they go away. They come down off their center stage role and take their rightful place in the back-row seat in the auditorium of your mind.

A BRIEF WORD ABOUT THE MEDIA

"I think it's unhealthy for girls to see these images of "perfect" celebrities because photos are often airbrushed. It's not reality."

– Faith Hill, singer[89]

The media portray fantasy, not reality.

"What people want is fantasy. But what they need is reality," Lauryn Hill proclaimed in her last "unplugged" CD. I couldn't agree more. We desperately need real people with real bodies to come on out of the woodwork and be seen.

I once had the opportunity to be part of the audience of a very good friend's TV talk show pilot. Her topic was body image in the media, and featured a panel of celebrity guests. One was Jennifer McCarthy, a celebrity who told us about

her big break modeling for Playboy. She humbly brought the poster of her centerfold up on stage and began circling—in huge, thick, black marker—all the parts of her body that had been altered. She circled where they had narrowed her inner thighs, thinned out her waist from both sides, falsely increased her cleavage, and erased all of her freckles. She told us that she hardly recognized the poster as her own image when it first came out. She thought she looked really good, but she knew that it was an inaccurate representation of her.

Next up was an interview of Kevin Richardson of the Backstreet Boys who told us about a rush job shooting the cover for an upcoming CD . It was a couple of days after Thanksgiving weekend and he felt bloated from feasting with his family. To increase sex appeal the producers wanted his shirt off for the shoot. He felt uneasy about this, not being in top form. "Oh, don't worry," one of the photographers said, "you can choose a pair of abs for the final proof." And that is exactly what they did. After the shoot, in the editing bay, Richardson chose one of ten "ideal" torsos that the editors simply spliced in to look like his.

And that's how it goes in Hollywood folks. No joke.

So we are comparing ourselves to entirely altered images, having no idea that what we are seeing is completely fabricated, while using every last drop of our blood, sweat, and tears to attain the impossible. And when we cannot, we hide our bodies, furthering the myth that what we see in the media is real.
It's no more real than the tooth fairy.

*That's CurvOlution
in a nutshell. Read on
for the details of our
CurvOlution Solution . . .*

GET OUT OF PRISON!
STOP WHAT YOU'RE DOING

"There's a lot of pressure on women and kids to look and be a certain way, and I don't agree with that. It's nauseating, it's depressing, and it makes people suicidal." – Pink, singer[90]

"Healing yourself is easy. Just stop doing what makes you sick and start doing what will create powerful health." – Richard Schulze, herbalist[91]

Question: Do you have so many rules and regulations regarding food and exercise that you practically need a calculator and personal secretary to keep them organized? Do you find yourself expending unnatural amounts of time and energy thinking, planning, and strategizing your food and exercise? Are you occupied by these annoying concerns at entirely inappropriate times of the day, particularly when you really should be paying attention to a friend or lover speaking to you, a teacher sharing information, or a boss giving you directions? Do you find yourself routing escape plans for how to break out and find yourself something sweet to eat in the middle of a meeting or a date? Do you try to hide how much you do or don't eat or do or don't exercise?

If you answer yes to many of these questions, then you are in jail—the mental, emotional, physical, and spiritual confines of a prison much more dangerous than a penitentiary lockup. This self-imprisonment leeches our very life force in tricky ways. It insidiously robs us of the pleasure of being in the moment. It fills us

Rachel's Rant:

As a healthy, real-bodied woman in America who's seen her fair share of diets, StairMasters, and media distortions, I know that we are fighting an uphill battle. But it's worth it. More importantly, it's possible. It is fully possible that we can come to love and accept our bodies. It may not be easy, but it is simple. The simple formula to loving our bodies combines unending persistence with a good dose of pretend. Persistence in the form of daily recommitment to adoring our bodies and treating them well. Pretend in the form of make believe. You know, fake it till you make it. Act as if you love your body until it comes true. Pretending is really good practice for the real thing. Keep pretending until one day it actually happens—you look in the mirror and adore yourself like mad. Remember, if you keep on doing what you've always done, you'll keep on getting what you've always gotten. So, let's kick out those old habits!

with shame for falling prey to our obsessive thoughts. It leaks our energy and robs us of intimate relationships, fulfilling moments, and precious self-love. When caught in the thickly webbed trap of compulsive thinking and behaviors of body-size control, we have little mind space left for creative endeavors that truly satisfy our souls. Our valuable consciousness is being overtaken by the world of frenzied, warped thoughts spurred on when we try to change our bodies.

This is a sentence worse than death. This is true hell on earth. This is where true change can come about. Buddhist wisdom states that we will only suffer as much as we tolerate. Meaning, as long as we tolerate these painfully overpowering, compulsive urges, we will continue to be held prisoner by them. When we get in enough pain, the kind of pain that we finally crumble underneath and can no longer tolerate, then we will make changes.

We may be forced to make scary changes, for we will be walking into the unknown. We may have only known the mental gymnastics that have governed our minds for years. These fiercely manipulative thoughts may have grown uncensored, unchecked for years like ivy, attaching to the walls that confine our minds. We may not even be able to conceive of a life without them. And often, we are more miserably comfortable staying with the known than letting go and venturing into the unknown.

I hope this will not happen to you. I hope you, too, will get into enough pain to take a stand and rally for change. Rally to get out of prison and into the light.

I hit bottom and made a commitment to change. I wish I could say it has been a smooth, easy ride since then. It has not. That was only the beginning. Life has a way of exciting us about its beginnings and then making us stay committed, mostly against our wills, to growth—if that is what we really want. Which means, on a daily basis, committing to moving forward, acknowledging our successes, reaching for more recovery, and staying as honest and true to ourselves as possible.

So what are the signs and symptoms of eating disorders? I think we all know the obvious, outward ones: Anorexics get really skinny and bulimics have puffy

faces and poor dental hygiene. Compulsive eaters become morbidly obese. But what about most of us who lie somewhere in between? Many eating and exercise disorders manifest far more internally than externally. The sufferer's inner thinking, behaviors, superstitions, and habits are really where most of the disorder manifests. And I would venture to say that the largest part of the disorder does indeed lie in those pesky, yet quite powerful, thoughts that tell us we're no good unless we look, eat, and exercise in an extreme way. Moreover, the telltale sign of disordered thinking is that we actually believe these extreme demands are normal and heed them.

So what in the world do we do when we identify these crazy voices? What happens when we call their bluff, shine the light on them, and see them for the ugly little worms they are? They're still there. They still haunt us. What are we supposed to do now?

First, separate your negative thoughts from who you are. You would no more have chosen those thoughts than shoot a bullet in your leg. You are not your damaging thoughts, and you don't have to believe them, especially if they are mean and nasty. Destructive beliefs have a pesky habit of multiplying themselves if we don't weed them out. The moment you first distance yourself from those scurrilous beliefs, you have introduced choice into your mindset. This is where freedom begins.

Make fun of them. See them for what they are, and take away their power by pulling down their pants. Stick your tongue out at them. Talk back to them. Tell them you are no longer interested in what they have to say. Do things behind their back and against their will. Think of the analogy of the angel and the devil on your shoulder. Kindly thank the annoying devil for sharing its boring old crap and promptly flick it off your shoulder. Choose to tune your ear to the heavenly tones of the angel on your other shoulder, who likes you and tells you so. When that mischievous, irritating little imp with the all-too-familiar voice comes back, which it will, repeat the flick-off-your-shoulder directive with determination.

Experiment with your power to change your internal reality. It's a rush. I am reminded of a brilliant scene in the movie *A Beautiful Mind*. Throughout

the whole first half of the movie, we are brought into the terrifying mind of a schizophrenic who is taken on dangerous adventures by his rampant, fear-based thoughts. By the end of the movie, the protagonist still sees all the characters, invisible to others, that taunt and torment him, yet they are further away from him, their voices slighter, and he is able to bypass their lure. The operative point is that he does indeed still see the people and hear the voices, but he has trained himself not to buy into them, not to listen to them. He distances himself and hence can see them merely as tormentors that he must no longer let rule his life.

I suggest we view all of our compulsive thinking in this way. The nagging voices do not necessarily go away. They simply fade into the background if we deny them our attention. We must literally starve out the voices.

We must also be willing to take a leap of faith and change our behaviors. There must be a point at which we are willing to change our habits, because they keep the voices loudly blaring in our heads. Insanity begets insanity. Overeating and overexercise beget more of the same. Puking begets puking and starving begets starving. At some point we must change. That can happen gradually or all at once, but one thing is for sure: All hell is going to break loose! There will be repercussions. All of those historic voices so invested in making us miserable and whipping us into obsessive submission will surely roar at the thought of being tossed aside for some sissy idea like health and moderation. No monster will go without a fight. And so we must gear up for the backlash of an old habit dying badly.

The only way to change the ancient manic machine is to consciously place a wrench in the monkey works. There is no alternative. We literally must begin, one thought at a time, one moment at a time, choosing to fill our minds with other thoughts. We have to introduce new, positive, barrier-breaking thoughts into the mix. They break up the cycle. They tear away the tenacious, ivy-like root system that's affixed itself to the walls of your mind. Imagine being a gardener faced with a huge, overgrown field full of weeds. The weeds on top of weeds are having a party in that field. They have fully taken over the soil

and become rulers. Your negative thoughts are like these persistent predators. You must become the gardener that first breaks up the weeds, tears out their root structure, plows and sows and refertilizes the landscape of your mind with positive thoughts, and plants new seedlings tied to your intentionally chosen growth stakes. Your new plants are your new thoughts. They are small and weak and vulnerable at first. They need the fortification of the stakes in the ground, standing firm and resolute next to them to guide their way upward. Those stakes are your repetitions. You must repeat and reiterate the positive thoughts and actions that reinforce your positive self-esteem.

REFLECTIONS

I can hear your doubting voices. They are loud, and rightly so. The negative voices in your head will die if you choose to believe all this. They are fighting for their cold, miserable lives right now. Just when you get a glimpse of hope, they must make sure to assassinate all forms of optimistic anticipation, or else. They don't want to die. They are greedy, stingy, power-hungry parasites that have been feeding on your poor self-esteem for years. They are not about to give up their stronghold on your psyche. The last thing in the world they want is for you to start believing you can change your thoughts. That would be the end of the world as they know it.

And, so I ask you this question: Are you in enough pain yet? Yes or no? Do you want to change? Yes or no? If you've answered yes to these questions, then I can share with you what has worked for me: Persistence. Dogged determination. Steadfastness. Insistence.

Insistence on what? Insistence on change. Persistence in starving out old, negative thoughts and repeating new, positive ones. Dogged determination that it works. Steadfast trust that you can change. Resolute faith that anything is possible, even changing those nasty, stinky, creepy old voices that have been with you for years.

I know it works. It's happened with me, and it can happen with you. I am no better and no worse than anyone reading this book. I am simply a woman born

in Ohio who was plagued by obsessive thoughts and actions that had me pinned to a circus wheel, prey to ever-flying daggers. I no longer suffer the insanity, day in and day out, that used to be my reality.

CURVO QUOTES
(IN YOUR WORDS)

"I, MYSELF, LIVE UNDER SIEGE FROM THE INNER CRITIC, THE JUDGE, AND THE 'PUSHER.' I'M STUDYING THESE SELVES OF MY PERSONALITY AND GIVING THEM NEW JOBS . . . FAR AWAY." – SARK, author[92]

"No matter how painful it has been, your relationship to your body can be redeemed."
– Camille Maurine, author[93]

"My friend's five-year-old niece was examining herself in the mirror one day. She turned to her mother and said, 'Mom, does my butt look big?' What is this world coming to?!" – Pat, graphic designer

CURVO INFO
(JUST THE FACTS)

"Harsh judgments about body acceptability create a nation of hunched-over tall girls, short women on stilts, women of size dressed as though in mourning, very slender women trying to puff themselves out like adders, and various other women in hiding. Destroying a woman's instinctive affiliation with her natural body cheats her of confidence. It pressures her to use up her energy worrying about how much food she consumes or the readings on the scale and tape measure. It keeps her preoccupied and colors everything she does, plans, and anticipates. It is unthinkable in the instinctive world that a woman should live preoccupied by appearance this way." – *Clarissa Pinkola Estes, author*[94]

⭐ CELEBRITY CURVOLATION
(WHAT THE CELEBS SAY)

"A couple of months ago, I was in a swanky New York hair salon, and the stylist who was doing my hair asked her six-year-old daughter what she wanted for lunch, and the girl, the six-year-old, screamed across the salon, 'A SALAD . . . JUST A SALAD . . . I DO NOT WANT TO GET FAT!' And I sat there with foil in my hair, and I started to cry. Because that girl is not rare. This isn't some girl from a documentary on _America Undercover_. No, she is more and more becoming the norm." – Kathy Najimy, actress[95]

"Women have to demand that it (body hatred) changes, and part of that is changing ourselves. And I do think it's possible, I really do. We just have to be vigilant about it. It's kind of like giving up alcohol. It's withdrawing from some fundamental addiction to self-hatred."

– Eve Ensler, playwright[96]

CURVO QUERY
(ASK YOURSELF)

- Have I suffered enough yet?

- Am I ready to stop suffering and start changing?

- Am I willing to try out new thoughts and new behaviors to get a new lease on life?

- Do I believe real change can happen?

- Am I willing to suspend my disbelief for the promise of a freer tomorrow?

CURVO TURBO
(TRY THIS CURVOLUTIONARY ACT)

Make a CurvOlutionary Commitment to change and know that it is possible. Commit to doing whatever is necessary to instigate change, especially if it means doing things way differently than you've done them in the past. You know the old saying: The definition of insanity is doing the same thing over and over and expecting different results. You must make a daily recommitment to yourself and your ability and right to change.

Likewise, be your own authority and authorize yourself to change. Allow yourself to shed old skin and become somebody different. It is said that the average person goes through six different careers in a lifetime. Imagine that you can shift entirely out of your old career of worrying about your body size all of the time, into a new career of loving your body unconditionally.

CURVOSIZE
(WHY EXERCISE WHEN YOU CAN CURVOSIZE?)

Exorcise through exercise. It is right about now that anger usually kicks in. We get mad at all the countless hours, weeks, months, and years we've spent toiling. Releasing anger can be really fun and great exercise. Ever thought of boxing, kickboxing, martial arts, or self-defense? These are good, positive, appropriate, healthy ways to exercise out all the anger you might have at old, stupid, obsessive behaviors.

AFFIRM THE CURVE
(POSITIVELY SWEET-TALK YOURSELF)

I now release all subconscious barriers to my personal health and growth and positive change.

CURVO TURBO
HOW TO BE A CURVOLUTIONARY

~

"The body image stuff just obliterates women's self-esteem. I'm never going to be the thinnest girl in Hollywood, or the smartest, or the funniest or the richest. I finally came to peace with that. You have to let go of that garbage if you're going to get anywhere." – Reese Witherspoon, actress[97]

"The first duty of a revolutionary is to get away with it." – Abbie Hoffman, political activist[98]

How do I do it? How do I stop obsessing? How do I stop waging a war on my body? How do I start accepting my body as it is? How? How? HOW?!

These are the most common questions asked as soon as I say we must stop obsessing and start accepting. Of course, much easier said than done, right? Well, right and wrong. It's really just a matter of being willing to try out something new. If your old ways of being are what got you in the pickle you're in, then certainly a new regime of thoughts and behaviors is in order.

So, we of CurvOlution decided to make it easy and fun. We call it CurvO TurbO—a jumpstart, a fuel injection, and a veritable G-force plan of action to catapult you into a super-duper, loving relationship with your body.

> **Rachel's Rant:**
> I know that it is our choice to love our bodies. The one thing we all have is our own free will. As Victor Frankel, a concentration camp survivor and author of Man's Search for Meaning says, the one thing in life no one could ever take away from him was his choice of how to think. No one could dictate how he thought internally. They could surround him with their propaganda, murder, torment, torture, and lies, but they absolutely could not take away his right and ability to freely think. We all have the absolute right to think and believe as we wish, no matter how many billboards say we are the wrong size and no matter how many boutiques don't carry our size.

CurvO TurbO comes from two rockin' words. CurvO stands for our beloved revolution of curves. TurbO is motion that can transform into power. Transformative motion that creates power. Cool, huh? So, put the two together, and what do you get? CurvO TurbO—our curvy revolution propulsing itself into transformational power.

Wanna take a test drive?

CURVO TURBO
(TRY THESE CURVOLUTIONARY ACTS)

DITCH THE DIET!
(STOP TRYING TO CHANGE YOUR BODY)

1

IT'S ALL ABOUT ME
(ACTIVATE A RADICAL SELF-LOVE THAT WORKS NOW!)

2

EAT AND GROW FIT
(EAT TO FUEL AND EXERCISE FOR VITALITY)

3

AFFIRM THE CURVE
(POSITIVELY SWEET-TALK YOURSELF DAILY)

EMBRACE YOUR SHAPE
(ACCEPT YOUR OWN UNIQUE BODY TYPE)

DITCH THE DIET!
STOP TRYING TO CHANGE YOUR BODY

~

"I go through waves with food.
If something cool is coming up and
I want to look good, I get into my
healthy fitness rage, but as soon as it's
over, it's like, 'Hurry, let's get pizza!'"

– Gwen Stefani, musician[99]

"To promise not to do a thing is
the surest way in the world to make
a body want to go and do that
very thing." – Mark Twain, author[100]

itch the diet! is our first CurvOutionary Act because we are all so neurotic about food. I was a dieting nightmare for many, many years, always giving in to the desperate idea that if I just altered my eating a bit this way or that, I could lose that magical couple of pounds that would make me happy and thin forever. Problem was, the more I dieted, the more insane I got around food, the more I wanted everything I was never allowed to eat, and the crazier I binged as soon as I could no longer stand it.

I was never able to love my body until I stopped trying to change it. Period.

Diets generate two things: obsession and fat. Did ya hear that? Again: diets create obsession and fat. Let's take a look.

In a famous study called the Ice Cream Test, a group of dieters and non-dieters were enlisted to eat ice cream. They were tricked into thinking they were taste-testing flavors, rating their favorites. However, the experimenters were actually looking for eating trends of dieters. So the group was divided into three subgroups, each consisting of both dieters and non-dieters. All three groups were given generous

Rachel's Rant:
Diets don't work. You name it, I've done it, and they all ended the same exact way: obsession, defeat, and resignation. Just say no, baby. Just say no.

bowls of ice cream to test. Now, here's the catch: Group One was given two milkshakes to drink before eating the ice cream, Group Two was given one milkshake, and Group Three was given no milkshake. So, what do you think happened? Let's look at the results in terms of the non-dieters' versus the dieters' reactions:

The non-dieters who had no milkshake prior to the bowl of ice cream heartily ate the ice cream. If they had one milkshake, they ate a little less ice cream, and if they had two milkshakes, they ate even less of the ice cream. Kinda what you might expect, right?

So, what do you think happened with the dieters? You guessed it—the exact opposite. The dieters who had no milkshakes ate moderate ice cream, the

ones who had one milkshake ate more ice cream, and the ones who had two milkshakes ate even more ice cream. Pretty interesting, huh? Pretty sad, really. So, you can see that normies (as I call them, people who are normal around food) stop eating when they get full. Dieters, however, eat *more* when they get full. Because of the psychological deprivation inherent to dieting behaviors, their natural fullness mechanism doesn't even kick in. As soon as they begin eating indulgent foods, there is no stopping, even well past the signs of fullness. In fact, a complete disconnect has happened between the dieter and her body. She has so distrusted and overridden its signals that the body no longer even sends them anymore.

Hence, dieting creates an obsession with getting what we've deprived ourselves of.

The other point, diets create fat, is even more fun and interesting to illustrate. I call this the Diet Drama in three parts. A woman goes on a diet. She drastically reduces her caloric intake, cuts out many energy-giving nutrients, and restricts herself from eating anything inherently tasty and satisfying.

Her body begins to starve.

Her body begins to defend its life.

Because our bodies have survived years of evolution with occasions of scarce food availability, they've learned how to defend themselves from starvation. Historically, they know that times of famine happen and will store fat away for such times. In this day and age, in our rich country, we have no such thing as famine. However, dieting mimics a famine. Our bodies read a state of diet-induced starvation the same way they used to read geographical scarcity of food.

So when you go on a "famine," as we like to call it, your body ingeniously enacts the following Diet Drama in three parts to defend its life:

Diet Drama, Part 1: The razor-sharp brain notices that the body is not receiving enough food. It starts to get a little panicked. It starts to get a little pissed. It starts to kick into action. It starts to stick up for the body. Like a looming drill sergeant, it blows a shrill scream throughout the body, specifically ordering, "Metabolism, HALT!!" So

the body, knowing to never trespass on the orders of the brain, slows its metabolism waaaaaay down to compensate for the lack of calories around. Low metabolism means you're not burning calories. Get it?

Diet Drama, Part 2: The all-mighty smart brain again notices that the body is starving. It sees the organs trying hard to function under insufficient nutrition. They are struggling just to keep themselves alive, but don't have enough energy from food to do their jobs properly. They are slowing down. The brain intervenes, knowing that there is another source of energy, aside from food, that the body can use to function: muscle tissue. Aha, the body realizes, we can simply break down muscle tissue and use it for food. Yes! Back in action. So, the body starts eating its very own muscle tissue as a form of food, reducing muscle mass, which, in turn, further reduces metabolism.

I don't know about you, but I personally like my muscles. They help me do trivial activities like, say, move, walk, carry, breathe, digest, smile, laugh, live.

Diet Drama, Part 3: The magnificently astute brain knows that this current diet-induced famine may be long-lived, or it may be temporary and come back. So the brain orders all fat cells to immediately expand. Expanded fat cells can store more calories for future starvation. So when food does finally come in the body, the enlarged fat cells now greedily hoard it, saving it away for the next time there is a shortage of calories. What's this mean? This means that by dieting, you have actually grown gigantic, greedy fat cells just waiting to balloon up the minute you finally give in and eat. Yuuuuuk!

Okay, so do you get the picture? Your decision to diet ensures that your fiendishly clever brain activates a three-part survival plan that fattens you up the minute food arrives on the scene. Your metabolism has shut down, your muscle density has lowered, making for even less fat-burning tissue around to eat up the calories, and your fat cells are partying hearty, bloated and beckoning those future food morsels into their gluttonous lairs.

So how do you stop dieting? These are the things to stop doing immediately:

Stop tallying, tabulating, computing, counting, calculating, compromising, compiling, scoring, graphing, analyzing, weighing, measuring, bargaining, finagling, tit-for-tatting, qualifying, judging, haggling, lying, cheating, promising, pleading, swearing at, and swearing off food. All these sniveling activities only increase Obsession Central. Nix it.

The answer? I'll say it again: Ditch the diet, baby! Stop trying to change the size of your body. All it does is create a subversive obsession with overeating and a body that now can't wait to get fat the minute you eat.

CURVO QUOTES
(IN YOUR WORDS)

"There was one diet where we ate a hard-cooked egg for lunch and two hot dogs for dinner, and I remember another where all we ate for three days were pineapple slices-we were allowed fifteen slices per day-five each at breakfast, lunch, and dinner. Highly nutritious, I am sure, especially for a child!" – Deborah, communications coach

"I WAS STUDYING TO BE A LIFEGUARD, AND I WANTED TO GET THIN TO LOOK GOOD IN A BATHING SUIT. YOU KNOW THE STORY. IT WAS SUMMER, SO I WENT ON THE CABBAGE SOUP DIET. IT WAS CABBAGE BOILED FOR THREE HOURS WITH ONIONS, CARROTS, AND TOMATOES. IT DIDN'T TASTE TOO BAD AT FIRST. AFTER A WHILE I HAD TO USE THE GAG REFLEX TO GET IT DOWN. AND IT GAVE ME LOTS AND LOTS OF GAS, THE MOST PUNGENT-SMELLING FARTS. I WAS SO WEAK I DIDN'T HAVE THE STRENGTH TO DRAG PEOPLE OUT OF THE WATER." – Moonshadow, artist

CURVO INFO
(JUST THE FACTS)

"Teenage girls who diet are more likely to become obese than their non-dieting peers, according to a new Stanford study. Led by Dr. Eric Stice, a Stanford postdoctoral fellow during the study and now an associate professor of psychology at the University of Texas, researchers tracked the weight and dieting habits of 692 teenage girls from ninth through twelfth grade.

"As the researchers write in the December 2004 issue of the *Journal of Consulting and Clinical Psychology*, overall the girls gained weight steadily during the four years, at an average rate of about three pounds per year. The rate of obesity also rose from 16 percent to 21 percent.

"Girls who had resorted to extreme weight-loss measures like laxatives and appetite suppressants were more likely to gain weight, as were those who had engaged in binge eating. Dieting, laxative, and appetite suppressant use, and exercise for weight loss, also greatly increased the likelihood of becoming obese, the analysis showed." – *Stanford Report*[101]

CELEBRITY CURVOLATION
(WHAT THE CELEBS SAY)

"I had been on this insane diet for almost seventeen years to maintain the weight that was demanded of me when I was modeling. My diet was really starvation. I am not naturally that thin, so I had to go through everything from using drugs to diet pills to laxatives to fasting. Those were my main ways of controlling my weight." – Carre Otis, model[102]

"My mother took it upon herself to make me eat steamed vegetables and salad. All my life, I figured that if I was going to work and look good, I had to starve myself. I don't know if I did it for long enough to be actually called an anorexic, but I definitely dieted to the point where I didn't look good anymore." – Portia de Rossi, actress[103]

"I have gained and lost the same ten pounds so many times over and over again, my cellulite must have deja vu." – Jane Wagner, playwright[104]

"I never worry about diets. The only carrots that interest me are the number you get in a diamond."
– Mae West, actress[105]

"THE SECOND DAY OF A DIET IS ALWAYS EASIER THAN THE FIRST. BY THE SECOND DAY, YOU'RE OFF IT."
– Jackie Gleason, actor[106]

CURVO QUERY
(ASK YOURSELF)

◉ Am I sick and tired of diets and their false promises?

◉ Have I tried enough diets to know that they never really work in the long run?

◉ Can I see how diets become a sort of false religion, promising gifts but never delivering?

◉ Am I willing to let diets go for good?

CURVO TURBO
(TRY THIS CURVOLUTIONARY ACT)

Make a CurvOlutionary Commitment to eat all foods that are nourishing and nutritional to your body. Keep all your commitments in the positive, focusing your energies on what you want, *not* what you don't want. Go beyond CurvOlutionary and never ever go on another diet again.

CURVOSIZE
(WHY EXERCISE WHEN YOU CAN CURVOSIZE?)

Exercise your right to choose foods that you love. Make sure they are tasty. And how about walking to the restaurant, the grocery store, the farmer's market? Get your exercise on the way to and from nourishing your luscious body.

AFFIRM THE CURVE
(POSITIVELY SWEET-TALK YOURSELF)

I eat to live!

IT'S ALL ABOUT ME
ACTIVATE A RADICAL SELF LOVE – NOW!

"If you're struggling to lose weight, just make sure it's not because the world wants you to." – Missy Elliott, rapper[107]

"To love oneself is the beginning of a lifelong romance." – Oscar Wilde, playwright[108]

You need to activate a radical self-love that works now. Not when you lose those five or ten pounds. Not when your wear the smaller size or your arms get toned or your cellulite is gone. We call that the When Syndrome. Bag it. Love yourself now. Right now.

I've worked with women who were thirty to fifty to a hundred pounds overweight who loathed themselves. And guess what? They dieted and/or exercised themselves down to normal or below-average weights and still despised themselves. They had no ability to love themselves when they were thin, because all they ever knew was self-aberration. They invariably fell prey to that nasty When Syndrome—when their bodies conformed to some other standard, they would be happy. Or so they thought. Unfortunately, no matter what size they dieted down to, they had no inner mechanism to switch into loving themselves. They'd practiced detesting themselves all their lives. It was all they knew. And the magical number on the scale or dress size couldn't even touch the amount of stored-up self-repulsion accumulated over the years.

Real change cannot exist inside of negativity. It will only boomerang or self-destruct. Real, solid, thorough change happens inside of love, nurturing, and positivity. I was navigating through my mountain of self-help books one morning for just the right affirmation for my day and came across this gem by William Goldberg: "I have never seen a person grow or change in a constructive direction when motivated by guilt, shame, and/or hate." Amen.

At this point, everyone, and I mean everyone, asks: So are we supposed to love ourselves even if we are obese?! The answer is yes. Love yourself to

> ### Rachel's Rant:
> I know that women are supposed to love their bodies. I know that it is our right to love our bodies. I think it is one of the commandments that we love our bodies. God told us so, right? If it's not a commandment, then it should be.

health. I am not advocating unhealthy obesity, as it is not optimal health and fitness. However, the only way to escort our bodies into healthful equilibrium is to love and care for them. Punishing them will result only in reactionary bingeing and other self-destructive, self-sabotaging behaviors. An analogy can be drawn to a failing, misbehaving, or misguided youth. If an adult shakes an angry, insulting, demeaning, and demanding finger at the confused youth, that child will usually react negatively with more of the same. If instead, an authority figure comes at the child with compassion, understanding, and loving acceptance, the young person will be infinitely more likely to acquiesce to more positive, forward-moving behaviors.

We must see the scared, lost teen as our own self and the angry versus accepting adult as our internal voices, either beating us into submission or loving us into making choices for our optimal health and fitness. To activate a radical self-love that works, it must be now—regardless of the outside circumstances of our physical body. And to do this, we must do for ourselves what we would do for someone we are madly, deeply in love with.

A favorite passage of mine from twelve-step literature reads, "I let no one—including myself—try to shame me into changing something about myself I wish were different. I pray to be relieved of guilt and self-hate, and to accept and like myself exactly as I am. That is where I can begin to change."

Let's quickly take a look at the inner mechanics of activating a radical self-love: In order for self-love to work in your life, two things must happen. First, you must pretend you love yourself if you don't already. Then you must also learn to suspend your disbelief that pretending doesn't work. It does. Remember when you were a kid? Wasn't it the bomb to get to pretend? Now you get to pretend yourself into self-love.

You must also suspend your disbelief that you are actually smarter than your brain. You probably don't think you can trick your brain into different thoughts. You can! Your brain is simply a computer that processes information. It does not know whether it is right or wrong, silly or destructive. It simply computes

the information you put in. So the thought "I love my body" is met with just as much acceptance as "I hate my body." Why not choose the thought that feels better?

Your body hears everything you think!

And moreover, thoughts are physical things. Thoughts are not just some mental masturbation that stays confined to your brain. Instead, thoughts are actually physical happenings. They are synaptically transferred, neuronal pathways that use chemicals called neurotransmitters to keep the thought moving and grooving. These neurotransmitters are tangible chemicals that then float throughout your entire body. Ever wonder why stress manifests in real physical symptoms like stomach ulcers, heart attacks, and high blood pressure? Your brain is not in your heart or your stomach, is it? But your thoughts or your "mind" circulates throughout every part of your body.

So negative, ugly thoughts disperse negative, ugly neurotransmitters all throughout your body. Imagine seeing "I hate my thighs" circulating stinky, negative chemicals all throughout your body. Whereas happy, positive, uplifting thoughts circulate happy, positive, uplifting neurotransmitters all throughout your body. Imagine seeing "My body is just right as it is" bathing pink, effervescent joy all throughout your body. It doesn't matter whether you are faking those thoughts at first or not. The point is that your body simply takes the data and acts accordingly.

So what I'm getting at is that when it comes to activating a radical self-love that works—fake it till you make it, baby! Fool your body into feeling loved by thinking and doing loving things. If you can believe it, you can achieve it.

So back to falling madly, deeply in love with ourselves. Remember those fresh, tingly, lovey-dovey feelings you've had for a new lover? Maybe you bought him flowers, wrote her love notes, talked sweetly to him, thought of ways to surprise her with gifts and thoughtful gestures? Now you get to do all those magical things for yourself! Imagine buying yourself flowers just for

the heck of it or writing yourself a love note in your fogged-up mirror: "Dear Rachel, you are amazing. Love, Rachel." Oh, the sweet audacity that we can actually dare to love ourselves boldly, brazenly, and bountifully.

How else can you prove your immaculate love for yourself? You can eat foods that are tasty, exercise in ways that make you sing, put yourself to bed when you are tired, buy yourself the music you love, surround yourself with your favorite colors and textures, nurture your inner artist with art supplies, say no to overextending yourself. You get the picture. The list goes on and on and on.

CURVO QUOTES
(IN YOUR WORDS)

"One of my best friends in college—a bit of a tomboy—used to say, 'Hey gorgeous, yeah you!' everytime she looked in a mirror. We all thought it was hilarious, but you know she is beautiful, even if she meant it as a joke."

– Melanie, computer programmer

"The way I activate radical self-love is actually through giving myself permission to go outside and play. Growing up, I wasn't allowed to do anything until my chores were done. As an adult, the work is never done. I am constantly giving myself permission to go outside, breathe, and move my body. It is completely decadent. Try it and see for yourself. Nature is divine, and being in it on a regular basis (not just vacations or weekends) is an amazing way to love yourself. It feeds my soul." – Nicole, production coordinator

"I MAKE SURE I TAKE TIME OUT OF EVERY DAY TO LOVE MYSELF. EVEN WITH MY CRAZY SCHEDULE, I MAKE MYSELF A PRIORITY. I GET UP AN EXTRA HOUR EARLY FOR THE THINGS THAT MAKE ME FEEL YUMMY, LIKE A HOT CUP OF TEA, SOFT MUSIC, JOURNALING, OR SOME LIGHT YOGA AND MEDITATION. THEN I ALWAYS CLOSE MY DAY WITH A HOT BATH AND DELICIOUS LOTIONS BEFORE I SLIP INTO BED."

– Michelle, health professional

CURVO INFO
(JUST THE FACTS)

"Adolescent girls today face the issues girls have always faced: Who am I? Who do I want to be? But their answers, more than ever before, revolve around the body. The increase in anorexia nervosa and bulimia in the past thirty years suggests that in some cases the body becomes an obsession, leading to recalcitrant eating behaviors that can result in death. But even among girls who never develop full-blown eating disorders, the body is so central to definitions of the self that psychologists sometimes use numerical scores of "body esteem" and "body dissatisfaction" to evaluate a girl's mental health. In the 1990s, tests that ask respondents to indicate levels of satisfaction or dissatisfaction with their own thighs or buttocks have become a useful key for unlocking the inner life of many American girls ." *– Joan Jacobs Brumberg, author*[109]

CELEBRITY CURVOLATION
(WHAT THE CELEBS SAY)

"I DON'T ENCOURAGE PEOPLE TO GO GET SURGERY.
I THINK THEY OFTEN DO IT FOR THE WRONG REASONS,
THINKING IF THEY HAVE BREAST IMPLANTS OR A
NOSE JOB, IT WILL MAKE THEM FEEL BETTER ABOUT
THEMSELVES. THEY CHANGE THEIR BODIES BUT HAVEN'T
DEALT WITH THEIR SELF-ESTEEM." – Queen Latifah, entertainer[110]

"I refuse to become part of this perfect-body
syndrome. I like my body. It looks good on-screen,
and it's not because it's perfect. I accept it and
wear it like a good dress. One guy I dated said:
'You're beautiful, but you're soft. You can't
compete with other actresses in Hollywood because
everyone's in shape and working out.'
I said: 'Very nice to meet you. Good-bye!'"

– Salma Hayek, actress[111]

CURVO QUERY
(ASK YOURSELF)

◉ Do I love myself enough?

◉ Am I willing to pretend I love myself until I do?

◉ What can I do to prove my undying love to myself?

◉ Am I convinced that I am worth loving?

CURVO TURBO
(TRY THIS CURVOLUTIONARY ACT)

Make a CurvOlutionary Commitment to loving yourself deeply and extravagantly. Leave yourself an adoring voice mail, write love notes to you on your mirror, call yourself darling, honey, and sweetie. Try it, you'll like it. You might just fall in love immediately.

CURVOSIZE
(WHY EXERCISE WHEN YOU CAN CURVOSIZE?)

Exercise to love yourself. Prove your dedication to your body through balanced and moderate exercise. Make your exercise into a devotional ballad to your body.

AFFIRM THE CURVE
(POSITIVELY SWEET-TALK YOURSELF)

I love myself.

EAT AND GROW FIT
EAT TO FUEL AND EXERCISE FOR VITALITY

~

"I ride my horse, walk my dog and swim in my lap pool at home. I do what I like and everything else takes care of itself. That's my motto now after years and years of trying to figure it out." –Portia de Rossi[112]

"Keeping your body healthy is an expression of gratitude to the whole cosmos - -the trees, the clouds, everything." – Thich Nhat Hanh[113]

F ill the tank and run the engine. Eat to fuel and exercise for vitality. Food is wood for the fire, and exercise is training for the body. A nice, cozy fire is lovely and priceless. Out of control brush fires scare, overwhelm, and overtake us. So it goes with food. Moderate food is kindling for a useful fire, whereas gratuitous, unhealthy foods are kerosene on a candle near a freely blowing drape—a disaster waiting to happen. Eat for your body's sake. Give it the foods it wants and needs to feel good and to have energy. A moderately trained body feels vital, alive, and rarin' to go. It has more energy than you know what to do with. An under-exercised body feels heavy, lethargic, and tired all the time. An overexercised one is in a constant state of repair, rebuilding, and recuperation.

Rachel's Rant:
I no longer use food or exercise to try to change the size or shape of my body. Why? It makes me crazy. I become a lunatic. I am not sexy, alluring, calm, peaceful, beautiful, or attractive. I am nothing that "watching my weight" or "controlling my food" is supposed to make me. Instead of becoming what the ads promise me, I become absolutely useless to society, insanely obsessing and compulsing every minute of every day.

Food is not the problem. Our relationship with food is the problem. I spent over a year living in Europe, and let me tell you, those people like their food and they are thin. When I was there, they did not have nearly the obesity or eating disorder rate we have. (Granted, I lived there more than ten years ago, and Americanization may be taking a higher toll on their culture now.) They did not have problems with food the way we do. They didn't stress about food like we do. They did not connive, manipulate, and carry on tormented, bipolar relationships with it the way we do. They ate a helluva lot of (gasp) bread, cheese, cream sauces, meats, and rich desserts, and drank copious amounts of wines and beers, especially late at night. Many of them didn't even eat dinner

until ten or eleven at night, and sat around the table until well past midnight with their families. Food, love, company, and communion went hand in hand. And guess what? They were thin. These statistics would put every American personal trainer and dieting manual out of business. It makes no sense according to all our diet-devout calculations about carbs and eating after 7 p.m.

It has less to do with the foods we choose and more to do with our relationship to the foods and our dysfunctional emotional connection with them. Now yes, of course, choosing to eat only freeze-dried, frozen, Crisco-puff, thoroughly processed, overly salted, and refined foods doesn't help. But again, I come back to the key here: Food, combined with love, in traditional cultures, marks regularly experienced times of togetherness, support, and nurturing between people. The food is a natural, joyous part of the expression of love and communion between the people. That makes all the difference.

Somehow a grave perversion has occurred here, and we've become entirely afraid of food. We have conversations with and about food as if it were alive, as if it had the nasty human qualities of our worst enemy. We grant it all sorts of evil, destructive, mysterious powers and carry on the most schizophrenic conversations about it. We anthropomorphize food, giving it human powers and making ourselves criminal for engaging in illicit relationships with it. "I was so bad, I ate that piece of cake." "That muffin was just calling out to me, screaming at me, and I couldn't say no." "Oh, I can't have that, it will go straight to my thighs." "Oh, *she* can eat that, but *I* can't."

Food and exercise need to reclaim their natural states in our lives. Our obsession with trying to change our bodies has tragically distorted food and exercise's roles. We've become deathly frightened of most food groups and preoccupied with forcing ourselves to do Olympian-like training in order to sculpt the ideal body. Phooey! It's no fun anymore! Food is supposed to be pleasing, sensuous, and enjoyable. Exercise is supposed to be releasing, exhilarating, and life-giving. Let's give them back their naturally pleasurable places in our lives.

As an ex-fitness professional who was either eating or on the treadmill, I intimately know the disappointing role each played when they were taken to their extremes. I was so afraid of food that I scarfed and hoarded it, hardly savoring a bite, forever obsessed with how I was going to get another one, or how I was going to burn that one off. And because I exercised far beyond my body's natural call, I never enjoyed it. I was always forcing it, perpetually tired and permanently stressed about making myself do more and more. Yuck! What a total drag!

I once had a male client desperately trying to change his physique through his diet. He wanted to increase his muscle mass so badly that he gave himself ventricular tachycardia from eating a pound and a half of chicken a day, overloading his poor arteries and heart.

It was not until I stopped using food and exercise for perverse, body-changing schemes that I was able to have peace and maintain a comfortably fit and settled body shape. If you want to lighten up your rapport with food and exercise, I recommend you take a crack at this tried-and-true trio:

1. Commit to no longer harming yourself with food or exercise. Do not hurt yourself with substances and activities that were inherently meant to enhance our bodies.

2. When you want to eat certain foods or exercise, ask yourself why? If your answer has anything to do with trying to change the size of your body, don't! Meaning, if you are choosing a low-carb, no-carb, no-calorie food because you think it will instantly make you skinny, stop it! It won't work (see "Ditch the Diet"). Likewise, if you are forcing yourself to exercise above and beyond what your body calls for because you think that extra hour in the gym will miraculously give you the "perfect" body—stop it! Right away! (Remember "Help I'm on the StairMaster.")

3. Commit to making loving choices. Remember, you've already committed to activating a radical self-love that works now!

Set yourself up for success instead of failure: Stop judging your food. Stop making quantifying and judgmental statements about your food, i.e., "I was so bad, I ate _____," or "I was so good, I ate _____." Both of these statements feed the obsession! You are either beating yourself up, thereby continuing the intense scrutiny of food, or you are setting yourself up for the inevitable ricochet binge after being really "good," also keeping your focus on food.

Stop analyzing your food. It's a deliriously dead-end cycle that keeps you enslaved forever.

Stop playing mind games with food. Stop the conversation about how much, how good, or how bad your choices were. Food is simply meant to be enjoyed as a sensuous way to fuel our body.

Remember that the difference between a "normie" and an "obsessee" is that a normie will occasionally overeat or make poor choices, but then will be done with the meal and move on. An obsessee will make that same occasional choice and then continue on the same course for hours and days, consumed by guilt, negative feelings, and retaliatory scheming. Total insanity. Lose it. Drop it. Let it go.

Set yourself up for success: Eat and move on. Literally. Stop quantifying, processing, and analyzing your food!

No matter what I eat, I bless it. I savor it. Whether it's a snack, a cookie, a salad, or a rich meaty casserole; I acknowledge its beauty, bless it, and know that it is nourishing my body.

So eat and grow fit. Fill that awesome tank up with yummy, luscious, nourishing foods and then take it out on the highway and race it like a sports car when the time calls. Don't be surprised if your body and appetite organically regulate themselves and you don't even have to monitor or force a thing.

CURVO QUOTES
(IN YOUR WORDS)

"Textures, flavors, smells, ahhhhh. The dichotomy of food. It messes with our emotions, we use it to literally kill ourselves, and yet we can't live without it. If only we didn't need it for survival. But since we do, developing a functioning relationship with it is crucial. So I say yes to food! Food is our friend, a friend that can heal us and revitalize us. So enjoy food; it is a gift. But next time you go for something that isn't good for you, just pause for a minute and ask your friend (food), 'Are you going to heal me or kill me?' Go with what feels right. Our bodies will tell us everything we need to know if only we would listen. Happy eating!" – Misty Tripoli, fitness pro

CURVO INFO
(JUST THE FACTS)

"In truth, weight has limited value as a measure of health, except probably at both extremes. Many people struggle to stay thin by restricting their nutritional intake when, in reality, average or even above-average weight coupled with physical fitness is the best assurance of health."
– Margo Maine, author[114]

CELEBRITY CURVOLATION
(WHAT THE CELEBS SAY)

"I'VE NEVER RUN A MILE. I TRY TO GO TO THE GYM THREE TIMES A WEEK. AND I HAVE TO WATCH WHAT I EAT. I'M A NORMAL PERSON. I'M SOFT IN THE MIDDLE, NO MATTER HOW MANY SIT-UPS I DO. I'M ALWAYS GOING TO BE FLESHY." – Jamie Lee Curtis, actress[115]

CURVO QUERY
(ASK YOURSELF)

- ◉ Do I use food and exercise to try and change my body?

- ◉ Does it ever really work for long, or do I end up frustrated, defeated, and obsessed?

- ◉ Am I willing to forge a new relationship with food and exercise?

CURVO TURBO
(TRY THIS CURVOLUTIONARY ACT)

Make a CurvOlutionary Commitment to eat for nutrition and exercise for vitality.

CURVOSIZE
(WHY EXERCISE WHEN YOU CAN CURVOSIZE?)

Okay, this is a simple one. Pick your favorite exercises and do them, a few times a week, for about an hour or so, regularly. Have fun. Mix it up. It's that simple.

AFFIRM THE CURVE
(POSITIVELY SWEET-TALK YOURSELF)

I lovingly fuel my body and vitally exercise my body.

AFFIRM THE CURVE
POSITIVELY SWEET-TALK YOURSELF DAILY

"I believe in eating, and I'm really happy that women are allowed to have curves again, to look like women, as opposed to waifs."

– Shannen Doherty, actress[116]

I t's also a fact that habitual thoughts multiply themselves. This is not only theory; it's been studied and documented by quantum physicists in the movie *What the Bleep Do We Know?* They studied those 80,000 thoughts, of which most are repeated and negative, and found that they actually pave a neurologically ingrained pathway to assist the next ones to travel in their wake. So yes, the more we keep thinking that our bodies suck, the more we keep thinking that our bodies suck. Conversely, pulling the plug on the negatives while adding in a good dose of new positives creates a sparkly new runway for happy flights in the form of helpful, encouraging beliefs.

If you want to experience freedom from obsession, you must change your thinking. However, you cannot will your thinking to change. That isn't going to work, trust me. The way to change your thinking is to start thinking different thoughts. The way to do this is to introduce a whole new cavalry of positive, peace-inducing beliefs. You must literally overtake the formally reigning negative thoughts with your new insurgency of encouragements. Out with the old and in with the new. Upturn the old downbeat majority with a raucous riot of radiance!

I suggest you arm yourself with a legion of positive thoughts and affirmations. You need to implement a system of thoroughly helpful thoughts to combat the old, nasty voices that have dominated you for so long. Affirmations are as old as time. They are not rocket science. They are simple and they are effective. If you do them. This means taking some time to write down all the old negative voices that have battered and bullied you forever, changing them into their loving, refreshing opposites, and reciting them as if your life depended on it.

> ## Rachel's Rant:
> Some statistic somewhere states something like (and don't quote me on these exact numbers, I was never great at science) we have 80,000 thoughts a day, 60,000 of which are repeats and 80 percent of which are negative. You do the math. It's gruesome—absolutely gruesome what our poor bodies and minds succumb to on a daily basis.

EXAMPLES:

I hate my body. ➡ **I love my body.**

My body is fat. ➡ **My body is gorgeous.**

There is something wrong with me. ➡ **I am perfect as I am.**

I will never change, I'll always be the same. ➡ **I am changing for the better right now. I am free now.**

So, I can hear you and all your voices right now. "No way. This is bullshit. Not another new-age person telling me to do affirmations. Affirmations, schmaffirmations. Nothing is going to change. Words can't help. I'm helpless; I've been this way forever. What do you mean, change my thoughts? How do I do that?"

They say the only true form of permanence is repetition. We become fear-based, compulsive thinkers by repetition. Our repetitive thoughts shoot through our heads like asteroids, coming from nowhere, going in any old destructive direction they want, and we are powerless over them. They repeat themselves over and over. We believe them and buy into them. These repetitive voices in our heads become our permanent reality. You know the ones: "You're fat. Your belly sticks out. You have big thighs. You're ugly. You don't deserve the guy because you're not pretty enough. If you were thin, all the guys would like you. If you had her flat belly, your life would be perfect."

And the best one of them all: "My life will be perfect when I lose just ten pounds." And the million variations on this theme: "My life will be perfect when my stomach gets flat, my hips trim down, my cellulite is gone, my boobs get bigger (or smaller), there is more space between my thighs, that fat underneath my arms disappears." Just fill in the blank: "My life will be perfect when

_____." Remember the When Syndrome?

You name it, we've got a repetitive tape that runs over and over, year after year. And the more the tape freely plays in our head, the deeper ingrained the thoughts get. Change the tape!

Positively sweet-talk yourself as much as possible. Come up with terms of endearment for yourself. Make affirmations that talk straight to your formerly berated parts. Tell them you love them. Tell the world you love them. Touch them as much as possible. I wake up in the morning, and the first thing I do as I get out of bed is gently rub my belly in circles, telling it I love it. No joke. And it works. Somewhere along the line, I've decided to believe this in spite of myself.

Terms of endearment are those names like sweetheart, honey, darling, boo, baby, etc. I will never forget the evening I sat in an eating disorder support group, and the woman speaking to us told us of a particularly challenging time she was going through. Her husband had gotten fired, they were in fear of losing their home, her mother was very sick, and she was scared. At that moment in telling us the story, she physically put her hand over her heart and stroked herself and said, "It's okay, honey." The "honey" she was referring to was herself. My life changed that day. I had never thought to speak to myself tenderly like that. To speak to myself like a caring, concerned mother would to her troubled daughter. To mother myself, in essence.

That day I began practicing it with myself. I would inwardly refer to myself as sweetheart. It felt stupid and fake at first. Really fake. But I persisted. And again, a change in my demeanor toward myself happened.

We essentially act our way into right thinking. So, by intentionally changing my internal messages, my thinking followed suit, and I began to actually believe I was a darling sweetheart.

Here are more affirmational transformations:

"I hate my body" ➡ **"I love my body! My body is juicy! My body is strong! My body is just right."**

"My thighs have too much cellulite" ➡ **"My thighs are gorgeously and lusciously feminine."**

"My butt is too big" ➡ **"My behind is attractive and alluring."**

"My belly is fat" ➡ **"My belly is sexy."**

"My breasts are too small" ➡ **"My breasts are just right."**

"My breasts are too big" ➡ **"My breasts are juicy and succulent."**

Now is your chance to have fun! Now you get to take your very own, uniquely negative self-talk, write it down, and come up with your own affirming statements. Practicing these regularly will again reinforce a new internal dialogue. You get the chance to act your way into right thinking by inundating your thoughts with these encouraging and uplifting statements until your old ones just wither away and die.

Affirmations also require two things: perseverance and acting "as if." Perseverance means you keep doing it over and over. Repetition really is the only form of permanence. Remember how many years your old thoughts have run rampant and unchecked like weeds. You must be committed to this process and to repeating it without fail. And what about acting "as if"? What's that? It's back to pretending again. It means that even though it will feel false, silly, and totally fabricated, you must still recite your affirmations. Make it a CurvO Ritual. You must pretend that saying your affirmations is working. Even if you don't believe it. You simply act like you could possibly believe the statements, and say them regardless of what your inner cynic says. You just keep repeating them no matter what. And one day they will become your stream of thoughts, easily and effortlessly. They will flow freely where the formerly nihilistic ones used to reign.

CURVO QUOTES
(IN YOUR WORDS)

"When you speak your affirmations, you are giving instructions to your subconscious mind. Daily practice of your affirmations is required for maintenance. It must be developed as a habit as necessary as brushing your teeth."
– Chellie Campbell, author[117]

"Thoughts become things. Choose the good ones."
– Mike Dooley, author and speaker[118]

"MAKE EVERY THOUGHT, EVERY FACT, THAT COMES INTO YOUR MIND PAY YOU A PROFIT. MAKE IT WORK AND PRODUCE FOR YOU. THINK OF THINGS NOT AS THEY ARE, BUT AS THEY MIGHT BE. DON'T MERELY DREAM—BUT CREATE."
– Robert Collier, author[119]

CURVO INFO
(JUST THE FACTS)

"The process of repetition-using affirmations can modify or create new beliefs about a person's identity and/or what is important to him (his values). Simple verbal repetition of statements intended to become new beliefs, values, or identity will result in these being stored for use by the RAS (reticular activating system, involved with value and belief storage). The longer the period of time affirmations are repeated, the higher the priority they are given in a person's value system and therefore the more they influence the person's behavior." – *performance-unlimited.com*[120]

CELEBRITY CURVOLATION
(WHAT THE CELEBS SAY)

"This is me. Like it or lump it. I had to starve myself for Titanic, and it just wasn't me."

– Kate Winslet, actress[121]

CURVO QUERY
(ASK YOURSELF)

- Do I talk negatively to and about my body?

- How many negative body thoughts a day would I estimate I have?

- Would I agree that I must counter those negatives with positives?

- I know how plant lovers swear that talking to their plants makes them happy and grow, right?

- What am I waiting for?!

CURVO TURBO
(TRY THIS CURVOLUTIONARY ACT)

Make a CurvOlutionary Commitment to say at least five to ten body-positive affirmations each and every day into the mirror, looking yourself straight in the eye—and believe them.

CURVOSIZE
(WHY EXERCISE WHEN YOU CAN CURVOSIZE?)

Women's bodies are curvy, and curves love to move. Especially in spirals and circles. Try Hula Hooping! What've you got to lose?

AFFIRM THE CURVE
(POSITIVELY SWEET-TALK YOURSELF)

My powerful and positive affirmations change my life for the better.

EMBRACE YOUR SHAPE

ACCEPT YOUR OWN UNIQUE BODY TYPE

"I finally realized that being grateful to my body was key to giving more love to myself." – Oprah Winfrey, media mogul[122]

"We cannot change anything until we accept it." – Carl Jung, analytical psychologist[123]

S o listen, folks. If you want to live in perpetual hell, keep trying to change your heredity. It's a winning recipe for disaster—staying eternally unhappy with the one fixed thing in your life—your DNA. I tried it for a solid thirty years. Great idea, Rach. Havin' fun yet? I ask you the same question. Are you having fun wishing you could magically turn into something you can never be? It's a party, ain't it?

If you've got thick legs, love 'em up cause they are what walk you through your life. If you have a compact waist and ample belly, get good n' comfy, cause it's assimilating your powerful life force. If you've got nice, wide hips that won't quit, might as well sit back and enjoy the ride; they're yours and no one else's.

The way I see it, you can either fight your body forever, or you can make friends with it. The result, physically, is the same. Your body will always be

> *Rachel's Rant:*
> *Wanna spare yourself a lifetime of jealousy, anxiety, depression, and obsession? Then stop trying to change your genetics. Accept your genes—they are the only ones you've got and the only ones you are ever going to have.*

your body. You can lovingly make it the best form of you possible. But it will always be just that—a form of you. It is never going to mysteriously change into someone else's body. Nor should it. It is doing just fine being you, carrying you through your life, isn't it?

So be cool and embrace your shape.

Accept and love the unique shape only you get to be.

Let's face it. We are born different sizes. Remember the baby ward? All the different lengths, weights, and proportions? We are different sizes. Period.

When we grow up, we make certain choices that do affect, to some extent, our body shape. Our food choices and exercise frequency can enhance or detract from our genetics. However, we do have a predetermined, genetically encoded set point that no amount of restricted food or excessive exercise will ever permanently change. When it comes to the size of our bodies, genetics play the

first and final role. I've had many friends with different proportions than mine. We would all watch our food and exercise, and no matter what, I always still ended up with tiny breasts, a thick waist, poochy belly, and shapely legs. Jackie always still had large breasts, a flat tummy, and soft legs. And Nicole always maintained her proud, upright chest, sloping belly, generous rear, and piston-strength short legs.

Remember that the media do not show us the Rachels, Jackies, and Nicoles of the world. In fact it doesn't show us very much of anyone we come across in our real lives. Current models are six inches taller, thirty pounds thinner, and twenty years younger than the average American woman. We see about 300 of these images daily. Furthermore, editors outright admit that they airbrush images that come across their desks, often carving out body parts or substituting them altogether with other, more "ideal" parts. Every single aspiring actress I've known in L.A. has told me that her agent said that she needed to lose at least twenty pounds and would be required to upkeep her looks with at least one plastic surgery a year to break into the business. (They were already stick-thin and gorgeous to start with.) The media are about fantasy, not reality.

Please read this: The most insidious, thwarting, hazardous impediments to embracing our shape are the well-intentioned "compliments" paid to us when we've lost weight or somehow changed the size of our body. They wreak havoc on our psyches. A frantic rush of thoughts overwhelms us: "Was I fat and ugly before? Was I unacceptable and unlovable before? Were you only noticing my fat before? Am I only loveable when I'm 'small'? Obviously my natural-size body is not acceptable. I must change my body to be loved. If this is how I get positive attention, then I have to keep doing this. In fact, I need to do more of it." And hence, the obsession is born and grows out of control.

Random comments about the size of our bodies, well intentioned or not, are extremely dangerous. They induce the raging despair that we can never, ever be okay as we are, but must change our body size in order to be deserving of love, admiration, and acceptance.

When other people innocently make remarks of approval and praise about
our body size, especially when it gets smaller, they've unknowingly committed
a mortal sin on our path to trying to healthily embrace our shapes. The minute
someone comments on our body size, they have lit a flame under the fire of our
mania. We then go into a tailspin all over again, re-equating our entire worth to
our body size. Every single woman I know, including me, feels uncomfortable,
unsettled, and conflicted when someone comments that they've lost weight.

I never, ever, under any circumstances make direct comments to women about
the size or shape of their body. Instead, if they look beautiful to me, I say, "You
look beautiful," or "You are glowing," or "You look so healthy and vibrant."

Remember that there are many reasons why people lose weight, one of which
might be that they are healthily shedding extra weight. More likely they are
forcefully trying to change their body through pathological behaviors, out of
their own hatred and non-acceptance of its form. I've had friends lose weight
and look "great" only to find out they were puking their guts out on a daily
basis. They later had to spend thousands of dollars and many years trying
to turn around irreparable health ailments with expensive medical care and
psychological counseling.

Do we really want to die to lose weight? Would we rather lie wasting in a
hospital bed, or live and embrace our shapes? Our nation is sick with this
creepy, life-robbing, insatiable desire to be thin. No one is teaching us to
embrace our shapes. When we are actually jealous of people on their deathbeds
because they have achieved our lifelong, ignoble aspiration to be thin, our
addiction has gone way too far.

And by the way, stop gawking and drooling at other people's "perfect" bodies.
The more you objectify other people's bodies, the more you are convinced
they are objectifying yours and the more you obsess about your imperfections.
It's called the property of projection. Remember that from "Psychology 101"?
Projection is assuming that others act or perceive similarly to us. In Freudian-
cum-CurvOution terms, if you are either idolizing or maligning someone else's

body, you can best be assured they are doing the same thing to you. Ouch. That hurts. Not very good for increasing the peace and embracing your shape. So control your urge to gawk.

Stop being a cog in the wheel of "perfect" body idolatry. As long as you worship textbook physiques, your own gorgeous shape remains underappreciated and underloved. Refuse to be a purveyor of the problem by averting your gaze away from impossibly lean bodies. It's just a pretty body, like a colorful jellybean at the candy store. It doesn't have magical powers; giving it hypnotic qualities is a bad habit. Kick it.

Ready to end the menacing war we've waged on our bodies? Then say yes to your body. It starts with you, right here and right now, saying yes to yourself. Feeling every healthy cell, muscle, bulge, and curve of that thriving body of yours. Being glad you are alive, that everything works right, and that you are capable of moving forward.

So it seems we'd do best to savor the hand we got dealt—and honor it. Love it. Can you imagine what it would be like if prizes were given out for all body types? If accolades lauded each kind of body for its unique strength and beauty?

Embrace your shape. Dress it elegantly, extravagantly, or practically. Fit it with clothes that feel good and express who you are. Feel its unique curves and covet the exceptional body type that only you get to have. Covet means to want to have something very much. Want your body! Be your body's biggest fan. It's all yours!

CURVO QUOTES
(IN YOUR WORDS)

"LET'S LAUGH AT CELLULITE! START A CELLULITE ACCEPTANCE CLUB. FIND WAYS TO MAKE FRIENDS WITH IT. I REALIZE THAT CELLULITE HAS STUCK BY ME ALL THESE YEARS—IT MUST HAVE SOMETHING TO OFFER. I ALSO THINK THAT IF WE COULD GET CELLULITE PUT ONTO BARBIE DOLLS, IT WOULD HELP A LOT WITH SELF-ACCEPTANCE."

– SARK, author[124]

"To the growing chorus of 'Fat is beautiful' that I keep hearing, let me propose that we expand that to 'All shapes and sizes are beautiful.' I'm rather thin myself, and always have been. So I read that men prefer curvy women and, for a moment, sigh. I suppose a backlash after the heroin chic of the '90s was overdue. But I believe that whether she's curvy, muscular, short, tall, athletic, thin, or big, as long as a woman exudes confidence in herself and her body, she is sexy. The message women receive nowadays should be less about 'Get bigger, curves are in!' or 'Lose weight, men hate a fat chick,' but rather, 'Be yourself, and men will love it if you radiate confidence.'" – Susan[125]

CURVO INFO
(JUST THE FACTS)

"Greater body acceptance brings about better self-esteem, less depression and anxiety, as well as healthier eating attitudes." – *Dr. Thomas F. Cash, author*[126]

CELEBRITY CURVOLATION
(WHAT THE CELEBS SAY)

"For twenty-five years, I could never put a forkful in my mouth without fear, without feeling scared . . . I'm sixty-three years old, and only in the last two years have I learned that good enough is good enough."

– Jane Fonda, actress[127]

"Beauty, to me, is about being comfortable in your own skin. That, or a kick-ass red lipstick."

– Gwyneth Paltrow, actress[128]

CURVO QUERY
(ASK YOURSELF)

- ◉ Do I embrace everyone else's shape but my own?
- ◉ How would it feel to embrace my very own shape?
- ◉ Can I try it?

CURVO TURBO
(TRY THIS CURVOLUTIONARY ACT)

Make a CurvOlutionary Commitment to embrace your shape.

CURVOSIZE
(WHY EXERCISE WHEN YOU CAN CURVOSIZE?)

Now that you're loving your very own uniquely shaped body that only you get to have, what better way to celebrate than some extra time and energy pampering yourself after your shower? I dare you to spend twenty solid minutes slathering yourself with your favorite aromatherapy scented lotion, paying attention to every single curve and crevice. Not only that, but really rub that lotion in, giving yourself an invigorating massage. This exercises you in two ways: First, it uses your muscles and requires strength, and second, it increases your circulation, which aids in your overall physical health. So you win times two! Remember to vigorously rub that lotion in! Get your blood flowing and give yourself the gift of touch! What could be better?

AFFIRM THE CURVE
(POSITIVELY SWEET-TALK YOURSELF)

*My shape is just right
because I say so.*

CURVO OUTRO
WAGING YOUR OWN CURVOLUTION

~

*"If you can stand up and say
'I love my body,' you can do anything.
I really mean it. If you can walk
in whatever body you own in the
world and feel good, you can stand
up to anyone."* – Eve Ensler, playwright[129]

*"[T]his very body that we have, that's
sitting right here, right now—with its
aches and pleasures—is exactly what
we need to be fully human, fully
awake, fully alive."* – Pema Chodron, Tibetan author[130]

Make no mistake, I started writing this book to save my life. It worked. Now, I finish this book hoping it will save yours and countless other lives, rescuing all of our lives from the greedy thief of body hatred and delivering us all to the haven of self-love.

May this book and these principles pierce you wide open. May they slay ye ol' nasty, uninvited gremlins of yore. They say that in order to truly heal, we must be willing to go back into the scary, ouchy, hurting places, shine the light of truth on them, and then apply the healing balm of love. May these words and your commitment to embody these principles be the healing salve that rids you of your demons once and for all.

Yes, I am a drama queen. Yes, this is all totally melodramatic. And, yes, we know that problems that have taken years to dig their dingy little talons into your psyche are not just throwing up dinky white flags and leaving on the next plane out. Growth, healing, and recovery are processes. If anyone knows this, it's me. My process has been long, organic, messy, and irritating at times. But the one thing that's gotten me closer and closer each day to freedom is faith: faith that the universe has something better in store for me. Faith that there is a whole lot more to life than spending my lifetime trying to change the dimensions of my flesh. (Not to mention funding every last hair-brained diet scheme, ice cream store, deli, and gym.)

I just couldn't get my mind around the idea that my entire lifespan would be summed up on my gravestone with the pathetic epitaph: "She was born. She got smaller. She died. Isn't that great." Life's got to have more in store for me than that! And that is why I wrote this book.

Hallelujah for wake-up calls. I hope this book has been a truth-ringing, in-your-face alarm clock for you and your body. My wish for you is that in these rants and raves and stories and suggestions you've found the secret gem underlying them all. The coveted treasure hunt clues that lead you to the boundless truth.

And what have all of these intimate revelations and painstakingly honest admissions been leading you to? What is at the crux? The core? What have all these chapters and anecdotes and quotes and funnies all been trying to help

you uncover? The golden nugget—what is at the soul of this book?

The answer is simple. Permission. Your permission. I am inviting you to give yourself permission to love your body now. You are the answer to your prayers. And your permission is required right now. I beg of you, plead, scream, kick, and throw a wild banshee tantrum, and then whisper sweetly in your ear:

Please, please, oh pretty please with chocolate mint sprinkles on top (I don't like cherries), give yourself permission right now to love your body.

You are allowed to love your body!

Now.

Not because I say so, but because you now say so.

So, yes, say it aloud, right now. I'm not talking in theory. No, I don't mean later, after you close this book and tell your friends about it. I mean right now. Say it out loud.

Come on . . . you can do it:

I love my body.

I am allowed to love my body.

Look out, world. We are here in our fierce, fabulous bodies. We are here, and we're not shrinking. We're not starving ourselves away or running ourselves down any more.

Ah, yes, thank you. Music to my ears. And, believe me, I can hear you, wherever you are and wherever I am. I've dreamed of this day for a long time. The day you and I and all of us say out loud . . .

I'm Beautiful, DAMMIT!

BIBLIOGRAPHY

Quotations from published interviews with celebrities and other individuals are used for purposes of information and comment pursuant to the Fair Use Doctrine. No sponsorship or endorsement by, or affiliation with, the quoted individuals is claimed or suggested. The names of some individuals have been changed.

1. Queen Latifah, "All hail the queen," Sciastia Gambaccini, *Glamour*, May 2004, 208.

2. something-fishy.org, website about eating disorders.

3. Gwen Stefani, "I'm Starving—Is the No Doubt singer getting carried away with a too-restrictive diet and a harsh exercise regime?" *In Touch*, 18 October 2004, 18.

4. Drew Barrymore, "Drew Barrymore's not so secret passions," Eric Bried, *Self*, September 2004, 178.

5. Gwen Stefani, "I'm Starving—Is the No Doubt singer getting carried away with a too-restrictive diet and a harsh exercise regime?" *In Touch*, 18 October 2004, 18.

6. Sheila Graham, quotationspage.com.

7. SARK. Reprinted with permission of Simon & Schuster Adult Publishing Group from *Succulent Wild Women* by SARK. Copyright © 1997 by SARK, 115.

8. Marc David, *Nourishing Wisdom*, Harmony/Bell Tower, reprint edition, 1994.

9. about-face.org, website promoting positive images of women and girls.

10. Society for Neuroscience, dedicated to advancing the understanding of the brain and neurosystem.

11. Dr. Sheila Forman, "Do you use food to cope?" iUniverse, Writers Club Press, 2002, 3.

12. Liv Tyler, *People News*.

13. Alicia Silverstone, http://en.thinkexist.com/quotes/alicia_silverstone.

14. Portia de Rossi, "Why Portia threw away her scale," *The Week*, 16 July 2004, 10.

15. Andy Rooney, quotegarden.com.

16. Courtney Thorne-Smith, "Ally McBeals's Courtney Thorne-Smith said she's fed up with the pressure to be thin," William Keck, *US Weekly*, 11 December 2000, 32.

17. Neil Armstrong, quotationspage.com.

18. ANRED.com, website for Anorexia Nervosa and Related Eating Disorders, Inc.

19. Joan Jacobs Brumberg. *The Body Project* by Joan Jacobs Brumberg, copyright © 1997. Used by permission of Random House, Inc., 123-124.

20. Paula Abdul, "Ask Paula: American Idol's queen of nice: Answers your questions," *Teen People*, June/July 2003, 81.

21. Julia Roberts, brainyquote.com.

22. Jennifer Lopez, brainyquote.com.

23. Gwendolyn Brooks, quotationspage.com.

24. Manual Pena, "The changing shape of a woman," Julia Savacool, *Marie Claire*, April 2004, 102-110.

25. Joan Jacobs Brumberg. *The Body Project* by Joan Jacobs Brumberg, copyright © 1997. Used by permission of Random House, Inc., 124-125.

26. Marion Jones, "Every size has its story," Sciastia Gambaccini, *Glamour*, May 2004, 214.

27. Kylie Minogue, bonkablebeauties.com.

28. Dolly Parton, brainyquote.com.

29. SARK. Reprinted with permission of Simon & Schuster Adult Publishing Group from *Succulent Wild Women* by SARK. Copyright © 1997 by SARK, 109.

30. Christiane Northrup, *Women's Bodies Women's Wisdom*, Bantam Books, 1994, 286.

31. breastnotes.com, educational website to help men and women understand the breast.

32. Jenny McCarthy, bonkablebeauties.com.

33. Anne Heche, ivillage.com.uk.

34. Lindsay Lohan, "The must list," *Entertainment Weekly*, 25 June/2 July, 2004, 66.

35. Paris Hilton, "Cover Interview," M. Ginsberg, *Seventeen*, October 2003, 62.

36. Calista Flockhart, brainyquote.com.

37. Madonna, brainyquote.com.

38. Albert Camus, quotationspage.com.

39. Stephen Phillips, quotegarden.com.

40. Judith S. Stern, ucdavis.edu.

41. A compilation of statistics from region.peel.on.ca, the Canadian regional government website for the region of Peel, and womensissues.about.com/cs/bodyimage/a/bodyimagestats.htm, quoting statistics from nationaleatingdisorders.com, the website for The National Eating Disorders Association.

42. Andie McDowell, "Every size has its story," Sciastia Gambaccini, *Glamour*, May 2004, 208.

43. Claudia Schiffer, brainyquote.com.

44. Raquel Welch, "The it body," Sarah Davidson, *O Magazine*, May 2004, 152.

45. Goldie Hawn, brainyquote.com.

46. Gypsy Rose Lee, brainyquote.com.

47. Nicole Kidman, celebwitty.com/t/Body-1.htm.

48. Rodney Dangerfield, quotationspage.com.

49. Jessica Weiner, *A Very Hungry Girl*, Hay House, 2003, 3.

50. Nancy Friday. From *The Power of Beauty* by Nancy Friday. Copyright © 1996 by Nancy Friday. Reprinted by permission of HarperCollins Publishers, 223.

51. Carolyn Murphy, "Every size has its story," Sciastia Gambaccini, *Glamour*, May 2004, 208.

52. Drew Barrymore, brainyquote.com.

53. Alanis Morissette, quotationspage.com.

54. ANRED.com, website for Anorexia Nervosa and Related Eating Disorders, Inc.

55. Camille Maurine, "Your real body," author's newsletter by Camille Maurine, author of *Meditation Secrets for Women*.

56. Shakira, "The Sexiest Woman in music today: Shakira," Nick Duerden, *Blender*, March 2003, 124.

57. Marcia Germaine Hutchinson. Reprinted with permission from *200 Ways to Love the Body You Have* by Marcia Germain Hutchinson. Copyright © 1999 by Marcia Germain Hutchinson. The Crossing Press, Berkeley, CA. www.tenspeed.com, 24.

58. Kathy Najimy, EDIN (Eating Disorders Network) speech in Atlanta, GA, kathynajimy.com/edin.htm.

59. about-face.org, website promoting positive images of women and girls.

60. Ibid.

61. Ibid.

62. Michelle Pfeiffer, zaadz.com/quotes/authors/michelle_pfeiffer.

63. Colin Farrell, askmen.com.

64. news.com.au, website for news from Australia and around the world.

65. CurvO Quotes: in his words (Stan, Eric, Curt, Dustin, Michael, Matthew, Gino), "Single-Minded: Curves, confidence and style," Jane Ganahl, *San Francisco Chronicle*, 3 April 2005, M2.

66. Queen Latifah, "All hail the queen," Sciastia Gambaccini, *Glamour*, May 2004, 208.

67. k.d. lang. "Big Boned Gal" by K.D. Lang, Ben Mink © 1989 by Jane Hathaway's other Co., Burnstead Prod. U.S., Inc., Zavion Ent., Inc. All rights administered by Universal-Polygram International Publishing, Inc. and Almo Music Corp./ASCAP. Used By Permission. All Rights Reserved.

68. SARK. Reprinted with permission of Simon & Schuster Adult Publishing Group from *Succulent Wild Women* by SARK. Copyright © 1997 by SARK, 106.

69. Carolyn Martin Shaw, "The changing shape of a woman," Julia Savacool, *Marie Claire*, April 2004, 102-110.

70. Anne Becker, "The changing shape of a woman," Julia Savacool, *Marie Claire*, April 2004, 102-110.

71. Camryn Manheim, geocities.com/tenorqueen/quotes.

72. Mia Tyler, wilhelmina.com/searches/tyler.html.

73. Jessica Simpson, interview about "In This Skin" from her album, *Reuters*, 18 August 2003.

74. Emme, geocities.com/tenorqueen/quotes.

75. Judith S. Stern, ucdavis.edu.

76. Joan Jacobs Brumberg. *The Body Project* by Joan Jacobs Brumberg, copyright © 1997. Used by permission of Random House, Inc., 128-129.

77. Tyra Banks, geocities.com/tenorqueen/quotes.

78. Hilary Duff, "Hilary Duff," J. Brown, *Seventeen*, August 2004, 156.

79. Jamie Lee Curtis, "Jamie Lee Curtis: True Thighs" Amy Wallace, *More*, September 2002.

80. Reese Witherspoon, "Regally Blonde," Leslie Bennetts, *Vanity Fair*, September 2004, 376.

81. Dr. Susan Brownell, "The changing shape of a woman," Julia Savacool, *Marie Claire*, April 2004, 102-110.

82. Jamie Lee Curtis, "Jamie Lee Curtis bares the truth," Ann Oldenburg, USAToday.com, August 19, 2002.

83. Eve Ensler, "The vagina is so yesterday—Ensler says it's now all about her stomach," Annie Nakao, *San Francisco Chronicle*, June 24, 2004, E1, E5.

84. Oprah Winfrey, quotationspage.com.

85. Debra Messing, Etonline.com, June 13, 2005.

86. Kate Winslet, brainyquote.com.

87. Drew Barrymore, "Icon: A whole new Drew," S.M. Smith, *Premiere Magazine*, November 2000, 70.

88. Eve Ensler, "The vagina is so yesterday—Ensler says it's now all about her stomach," Annie Nakao, *San Francisco Chronicle*, June 24, 2004, E1, E5.

89. Faith Hill, "Faith Hill and the wisdom of the divas," G. Hirshey, *Glamour*, October 2004 supplement, 26, 28.

90. Pink, "Shaking things up," Dorian Lynskey, *Blender*, November 2003, 98, 101.

91. Richard Schultze, quoted from the walls of his American Botanical Pharmacy, Marina del Rey, CA.

92. SARK. Reprinted with permission of Simon & Schuster Adult Publishing Group from *Succulent Wild Women* by SARK. Copyright © 1997 by SARK, 114.

93. Camille Maurine, "Your real body," author newsletter by Camille Maurine, author of *Meditation Secrets for Women*.

94. Clarissa Pinkola Estes, *Women Who Run with the Wolves*, Ballantine Books, 1996, 201.

95. Kathy Najimy, EDIN (Eating Disorders Network) speech in Atlanta, GA, kathynajimy.com/edin.htm.

96. Eve Ensler, "Body language, an interview with Eve Ensler," Jessica Werner, June 24, 2004, act-sf.org/goodbody/tgb_int_jes.htm (American Conservatory Theater Website).

97. Reese Witherspoon, "Regally Blonde," Leslie Bennetts, *Vanity Fair*, September 2004, 376.

98. Abbie Hoffman, quotationspage.com.

99. Gwen Stefani, "I'm Starving—Is the No Doubt singer getting carried away with a too-restrictive diet and a harsh exercise regime?" *In Touch*, 18 October 2004, 18.

100. Mark Twain, quotationspage.com.

101. Stanford Report, "Researchers find teen dieting associated with weight gain and obesity," Mitch Leslie, Jan. 5, 2000.

102. Carrie Otis, caringonline.com/eatdis/people.htm.

103. Portia de Rossi, "Why Portia threw away her scale," *The Week*, 16 July 2004, 10.

104. Jane Wagner, quotegarden.com.

105. Mae West, brainyquote.com.

106. Jackie Gleason, soupsong.com.

107. Missy Elliot, "Work it! Rapper M. Elliot gets into fitness," E. Kennedy, *Vibe*, February 2003, 120.

108. Oscar Wilde, wikiquote.org.

109. Joan Jacobs Brumberg. *The Body Project* by Joan Jacobs Brumberg, copyright © 1997. Used by permission of Random House, Inc., 24.

110. Queen Latifah, "Latifah reins in the curves," Ann Oldenburg, USA Today, 31 July 2003, 2D.

111. Salma Hayek, celebwitty.com.

112. Portia de Rossi, myweb.ecomplanet.com/SYLV4264/mycustompage0006.htm.

113. Thich Nhat Hanh, quotationspage.com.

114. Margo Maine, *Body Wars*, Gurze Books, 1999, 36.

115. Jamie Lee Curtis, "Starring as herself," M. Grant, *Reader's Digest*, December 2004, 91(7).

116. Shannen Doherty, *Spin*, June 2003, 46.

117. Chellie Campbell, *The Wealthy Spirit: Daily Affirmations for Financial Stress Reduction*, Sourcebooks, 2002, 2.

118. Mike Dooley, tut.com (Totally Unique Thoughts), website promoting positive thinking.

119. Robert Collier, brainyquote.com.

120. performance-unlimited.com, website promoting wellness products and services.

121. Kate Winslet, "As Kate would have it," H. Millea, *Premiere*, November 1999, 104-110.

122. Oprah Winfrey, quotationspage.com.

123. Carl Jung, en.thinkexist.com/quotes/carl_gustav_jung.

124. SARK. Reprinted with permission of Simon & Schuster Adult Publishing Group from *Succulent Wild Women* by SARK. Copyright © 1997 by SARK, 105.

125. "Single-Minded: Curves, confidence and style," Jane Ganahl, *San Francisco Chronicle*, 3 April 2005, M2.

126. Thomas F. Cash, *The Body Image Workbook*, MJF Books, 1998, 3.

127. Jane Fonda, caringonline.com.

128. Gwyneth Paltrow, brainyquote.com.

129. Eve Ensler, "Body language, an interview with Eve Ensler," Jessica Werner, 24 June 2004, act-sf.org/goodbody/tgb_int_jes.htm (American Conservatory Theater Website).

130. Pema Chodron, quotationspage.com.

Beauty is not a size

We hope that we've inspired you, made you laugh, made you cry, and most importantly helped you to love your body more! If this book was helpful to you, we invite you to be a CurvOlutionary. CurvOlution provides tools, programs, and events to help empower girls and women to love their bodies.

SO, ARE YOU READY TO JOIN THE CURVOLUTION?

Here's how: To bring Rachel to speak and present her *I'm Beautiful, Dammit!* **workshop** to your community, school, or special event contact **Tonya Sandis**, co-founder of CurvOlution, at **tonya@CurvOlution.com**

Win CurvOlutionary prizes: Tell us your story! Dying to share?! Go to **www.CurvOlution.com** and fill out our *In Your Own Words* survey. We want to know your own personal stories and your testimonials about how this book has changed your life.

Stay abreast of CurvOlution's activities: Join our newsletter. It's a must-read for the avid CurvOlutionary! Go to **www.CurvOlution.com** and click on *Join our Newsletter.*

Be a CurvOlutionary Affiliate: Join our book program—because every woman should have this book! Visit **www.CurvOlution.com** and click on *Book Program*, where you can order books in bulk at a discount for your fundraisers.

CurvOlution and the CurvOlution logo are trademarks of Tonya Sandis and Rachel Caplin. Used under license.